SCOTLAND REVEALED

SHAHBAZ MAJEED

AMBERLEY

First published 2020

Amberley Publishing
The Hill, Stroud
Gloucestershire, GL5 4EP

www.amberley-books.com

Copyright © Shahbaz Majeed, Frame Focus Capture Photography, 2020

The right of Shahbaz Majeed to be identified as the Author of this work has been
asserted in accordance with the Copyrights, Designs and Patents Act 1988.

British Library Cataloguing in Publication Data.
A catalogue record for this book is available from the British Library.

FOREWORD BY BRIAN COX

As someone who is away from Scotland often, a book such as this is a powerful reminder of the beauty and drama of home. I'm really pleased that Shahbaz has revisited some of the most awe-inspiring of Scotland's landscapes and has put together another stunning volume of work in which to showcase them.

United in these pages are the physical fabric of mountain, coast and town with the human and cultural aspects of place and history. Through these images we can yet again grasp the vastness of what Scotland has to offer and cannot help but evaluate our place in it. Shahbaz, once again, directs his camera with such imagination and wisdom to capture the unrivalled majesty of home, setting the scene for us many times over.

Looking through the images makes this proud Dundee man eager to explore once more the grandeur on offer to all who visit this beautiful country.

Image by David Ho

ACKNOWLEDGEMENTS

When I did my first book, I was not expecting to be asked to put together another in such a short period of time, so it would be amiss of me not to thank everyone at Amberley Publishing for putting their faith in me once again.

So here we are with the next instalment of a tour of this wonderful country.

Of course, my lovely wife Shazia has been ever supportive as well as my amazing dad, Abdul, and they deserve being singled out again for this book. My girls, now obviously a bit older, love the fact that their father has his own book and are always proudly telling strangers about this. Not only that, I now get asked by them why I am not away somewhere at the weekend taking photos for the next one… Ouch!

Getting a bit more serious for a moment, some of those reading this will know that the last few years have been, well, challenging to say the least. Most of what has been going on in my life you simply couldn't make up and when I have discussed it with some of you, even you cannot believe the stories I have to tell.

Saying that, all of my close friends (and you know who you all are) have been such a rock in difficult times that this book is very much dedicated to you all, who have done more for me and my family than you will ever know. Whether it is just to listen to me over lunch or whilst we head out on a photography jaunt and I bore you senseless with my ramblings the entire journey, I cannot possibly thank you enough.

One day, I might even share my writings of these events just to allow everyone else to read about what has been going on, but for now, life goes on. This is where travelling and going out taking photographs, especially with the family in tow, has been a welcome relief and going through the images in this instalment reminds me of many many tales that I would love to share one day.

Putting my own experiences to one side, there are some of my friends who have been going through their own battles and they have been unable to join me on our regular photography trips. I know how disheartened you have felt, especially seeing some of my images for this book, but it won't be long before we can carry on where we left off! So many places still to visit, and it's not the same without us all there, so I look forward with anticipation to when we can start those trips again.

I was so honoured to have the amazingly wonderful Brian Cox write the foreword for my first book that I had to have him write one again for this volume. I am lost for words in expressing my gratitude to such a humble person who again gave his precious time to support this instalment. Of course, not forgetting Brian's PA, Vanessa Green – you are such a wonderful person too.

My oldest daughter has started joining me on some of my outings and enjoys taking her camera whilst my youngest is upset she doesn't get to go all the time too, but it won't be long before they both get to accompany me all the time if they wish. Who knows, maybe a joint book is in our future.

Thank you all again.

ABOUT THE PHOTOGRAPHER

Shahbaz Majeed was born and raised in Dundee, Scotland, and has been taking pictures for over a decade.

Over the years he has won numerous competitions and awards for his work – at national and international levels, in some of the biggest photography competitions attracting entries in the hundreds of thousands.

Some of his clients include prestigious brands such as the V&A, VisitScotland and Microsoft and he has had one of his images featured on UK currency on two separate occasions. Shahbaz's belief is that we as photographers have an important job not just to document our surroundings but to share our work in order to promote the beauty of the world to others. By sharing our knowledge with others, not just to inspire future generations of photographers, but to also push the boundaries and quality of our own work, we will inevitably raise the game for the better.

The images in this book have been taken on a variety of cameras and lenses and using various accessories:

Cameras: Canon 5D / Canon 5D Mk II / Canon 1-DX / Phase One IQ3 80 / Phase One IQ3 100 / Canon R

Lenses: Canon EF 11-24mm / Canon EF 24-70mm / Canon EF 24-105mm / Canon EF 50mm / Canon EF 100-400mm / Schneider Kreuznach AFD 28mm / Schneider Kreuznach LS 35mm / Schneider Kreuznach LS 80mm / Schneider Kreuznach LS 240mm / Canon EF 70-200mm

Accessories: Gitzo Mountaineer Tripod / Lee Filters / Hitech-Formatt Filters

www.framefocuscapture.co.uk

Image by Kristy Ashton

INTRODUCTION

My first book, *Scotland in Photographs*, was for me a huge success (and thankfully for the publishers too!). I didn't know how the book would be received by the public but the book signing and the publicity events that had me featured on national radio and press and even a TV appearance were beyond my expectations and my dreams.

It is hard to describe the feeling of being in a bookshop or visitor centre and seeing your book on display, sneakily listening to those browsing through it and hearing their comments. Thankfully, the comments have been wonderful and humbling and I am amazed at where the book has made its way to, becoming a firm favourite with visitors to our shores.

I hope this instalment also meets your expectations and more importantly continues to encourage more visitors and those who live here to continue to explore areas that are less familiar to them. If you have been to these locations and don't think there is anything new then rest assured no two visits are ever the same, and often not too far from the iconic spots you can find some other gems that are less visited.

Scotland is a magical place in that the landscape is one of the finest (if not the finest) anywhere in the world and to be able to showcase it again in this book, to so many people, is a privilege and an honour.

Welcome back to exploring Scotland.

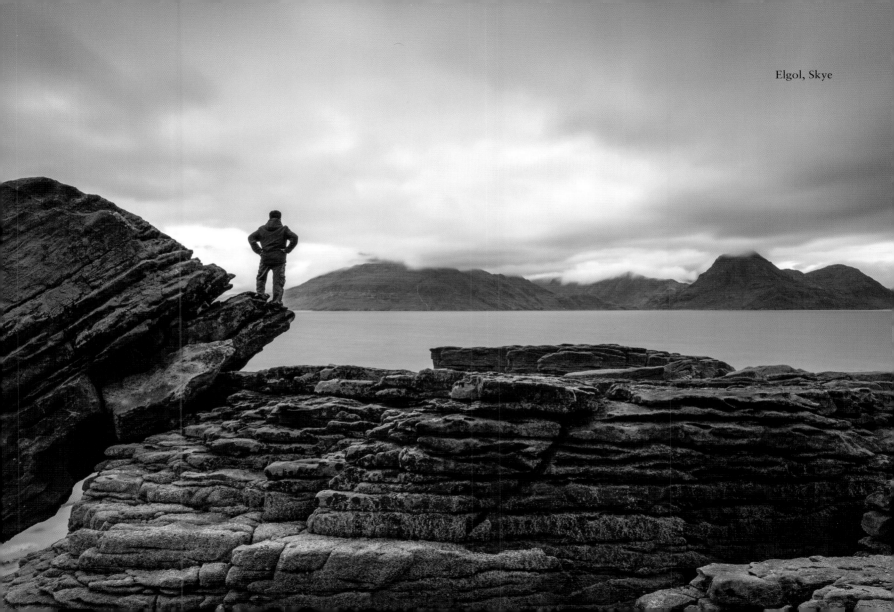

Elgol, Skye

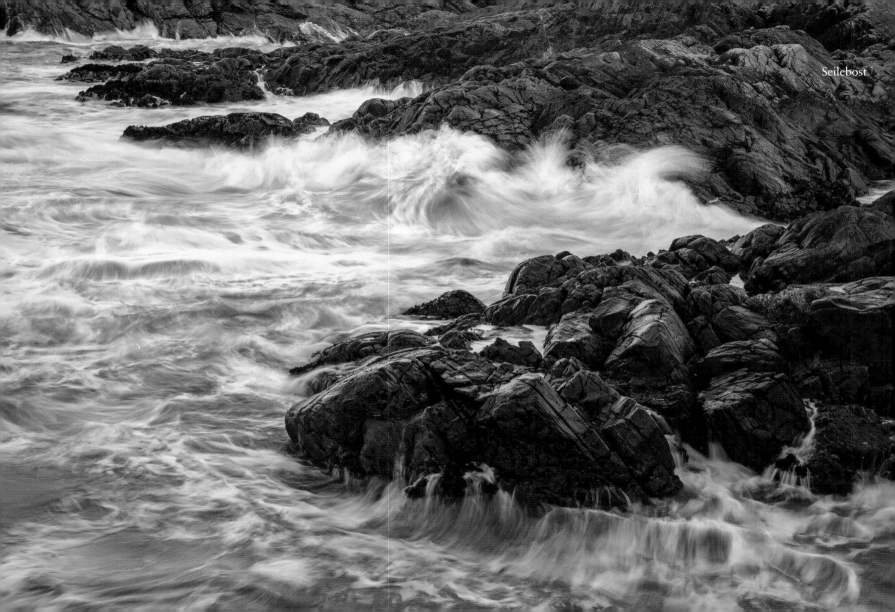

Seilebost

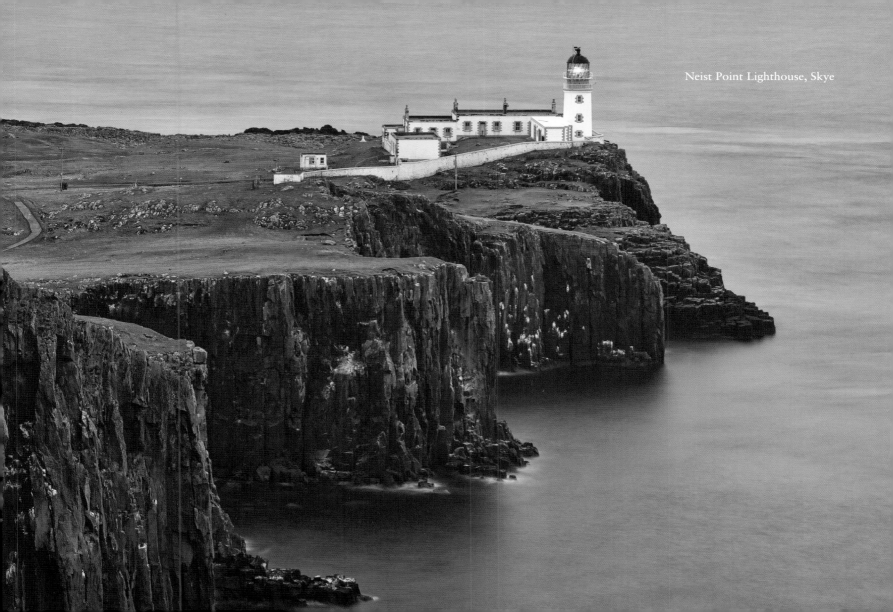
Neist Point Lighthouse, Skye

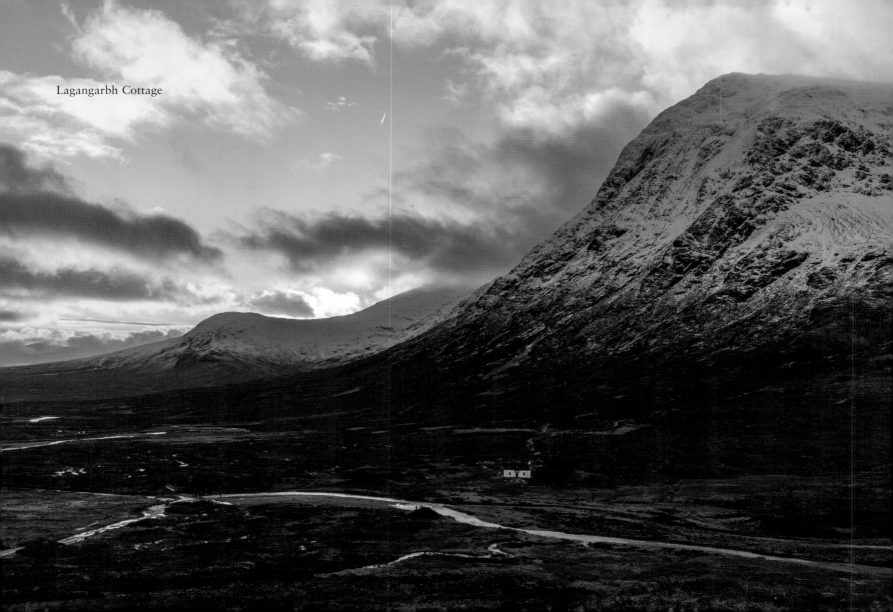

Lagangarbh Cottage

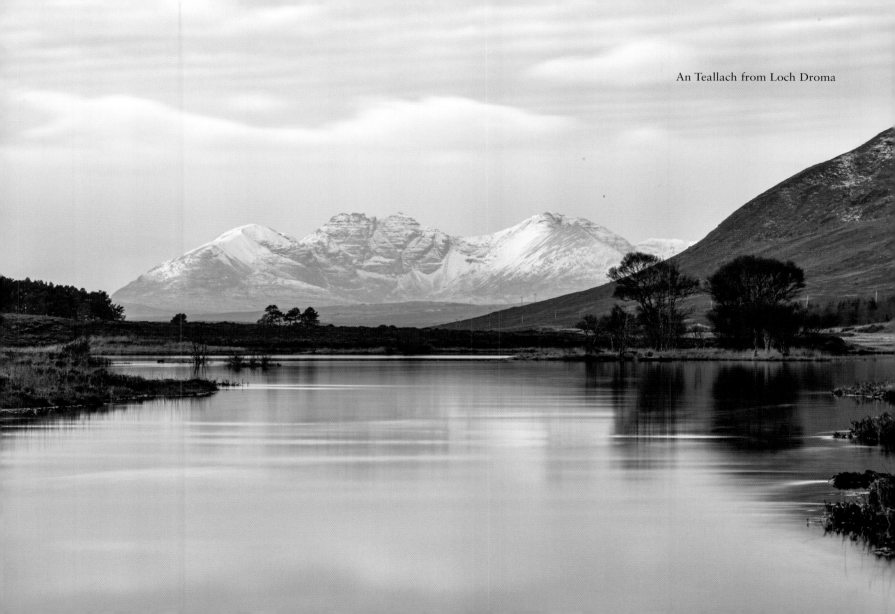

An Teallach from Loch Droma

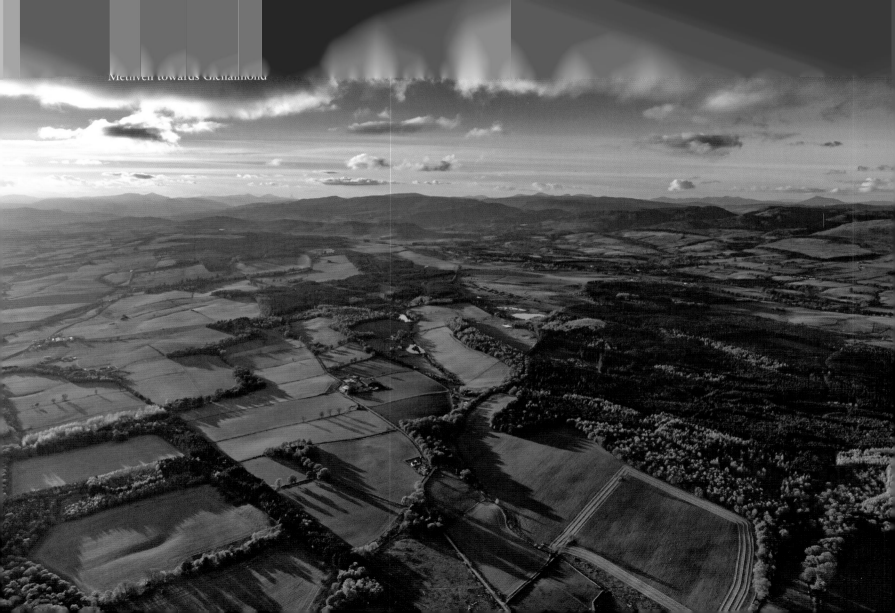
Methven towards Glenalmond

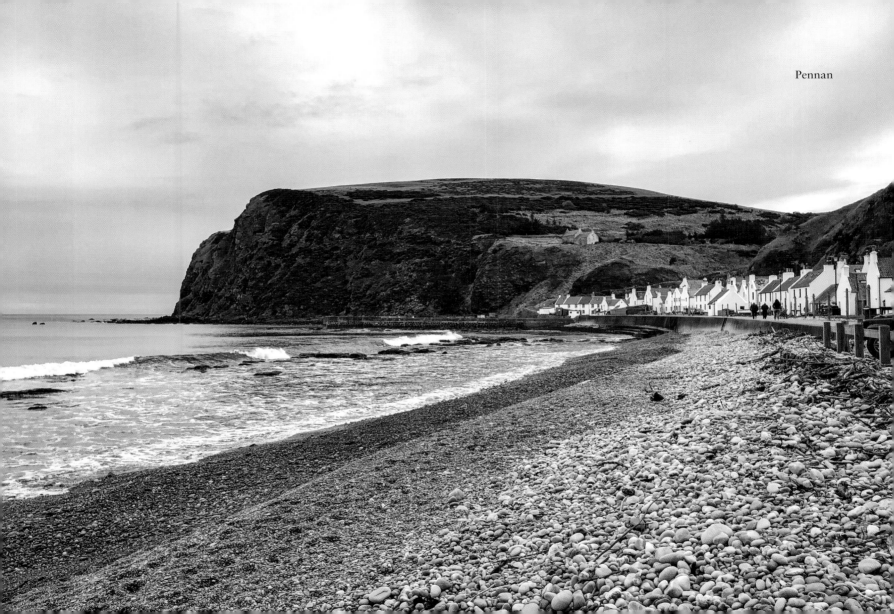

Pennan

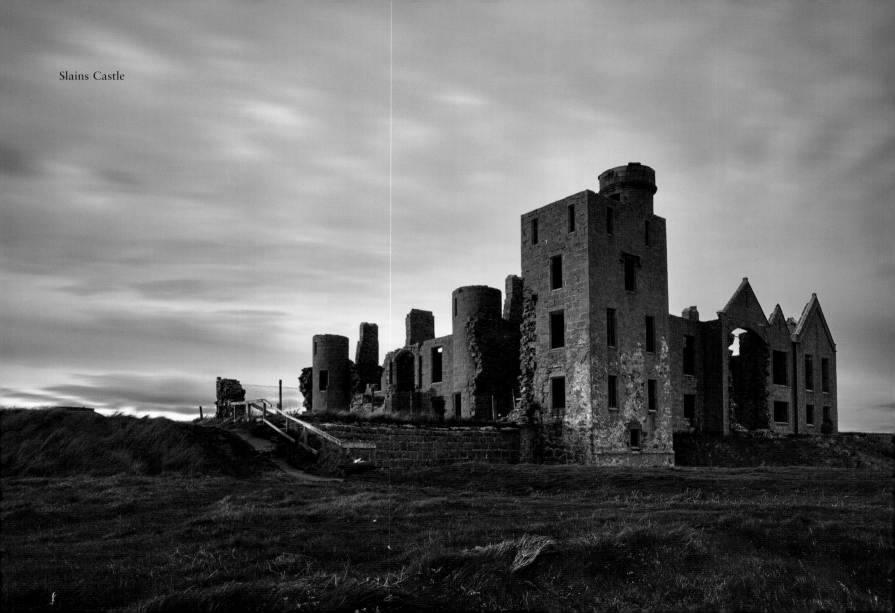
Slains Castle

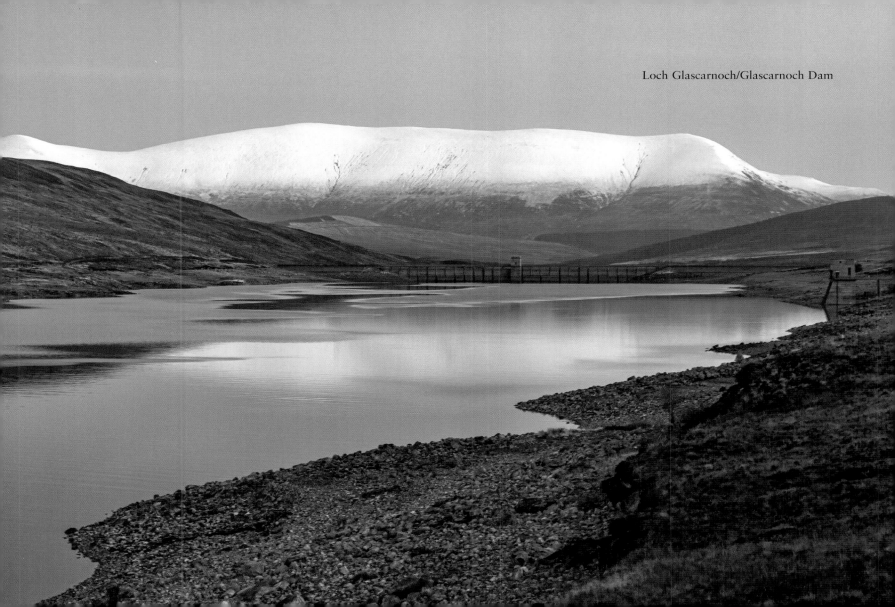

Loch Glascarnoch/Glascarnoch Dam

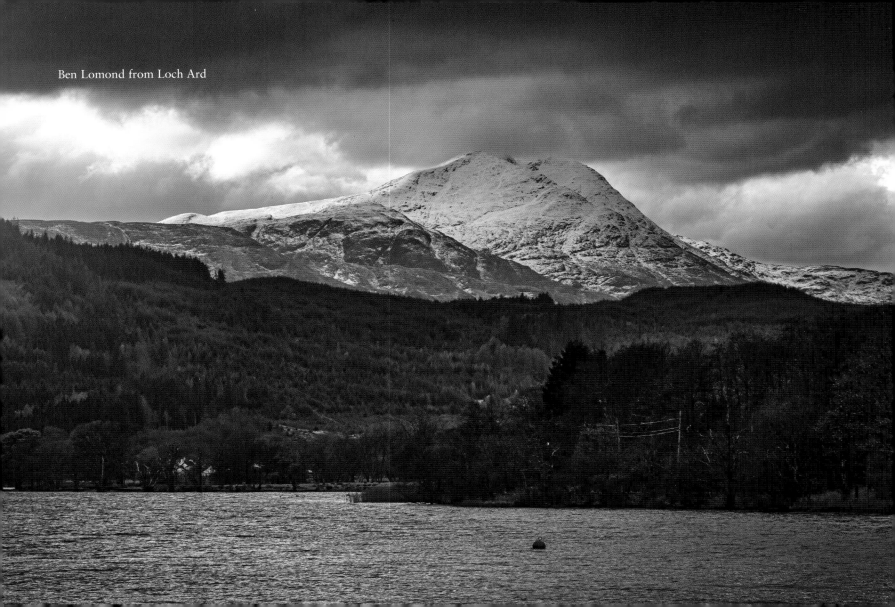

Ben Lomond from Loch Ard

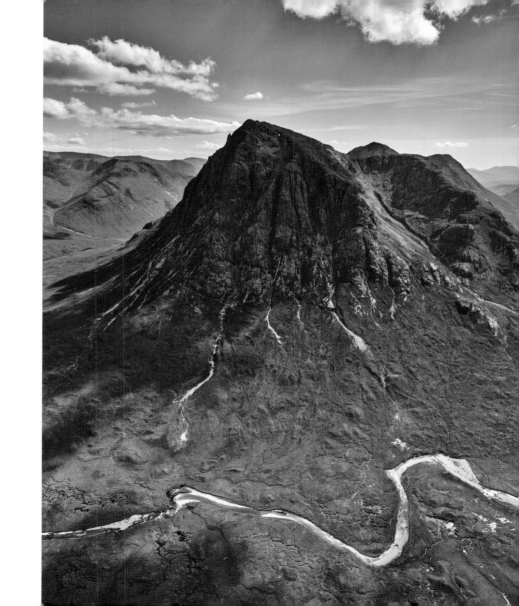

Buachaille Etive Mòr

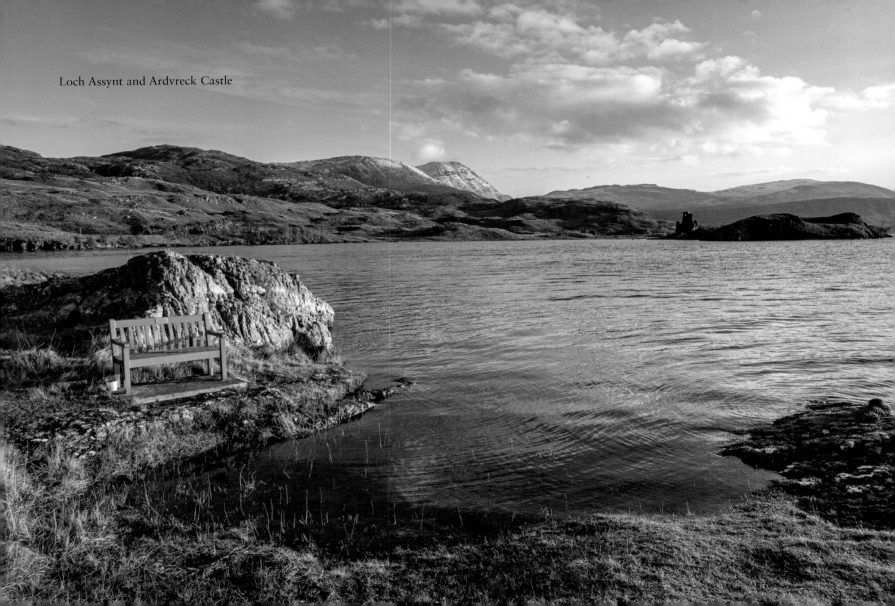

Loch Assynt and Ardvreck Castle

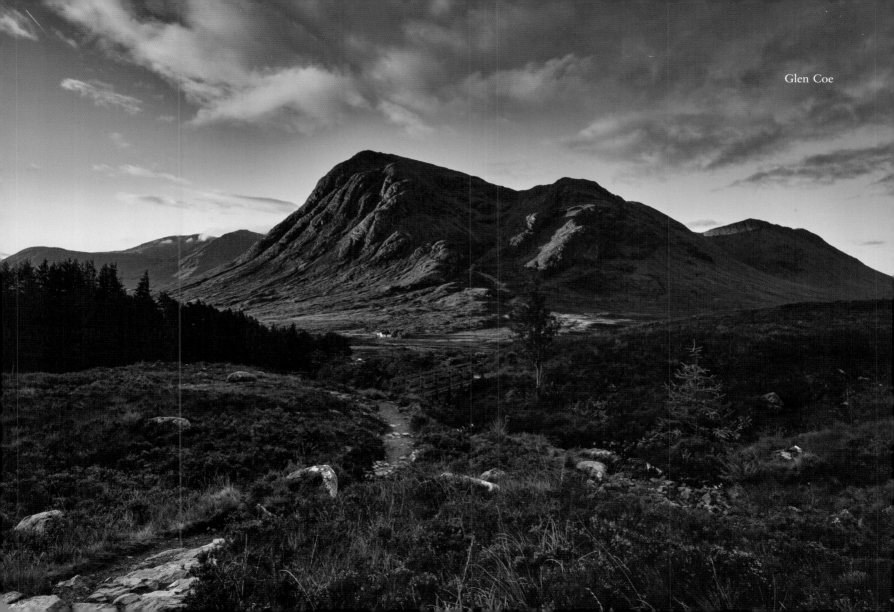

Glen Coe

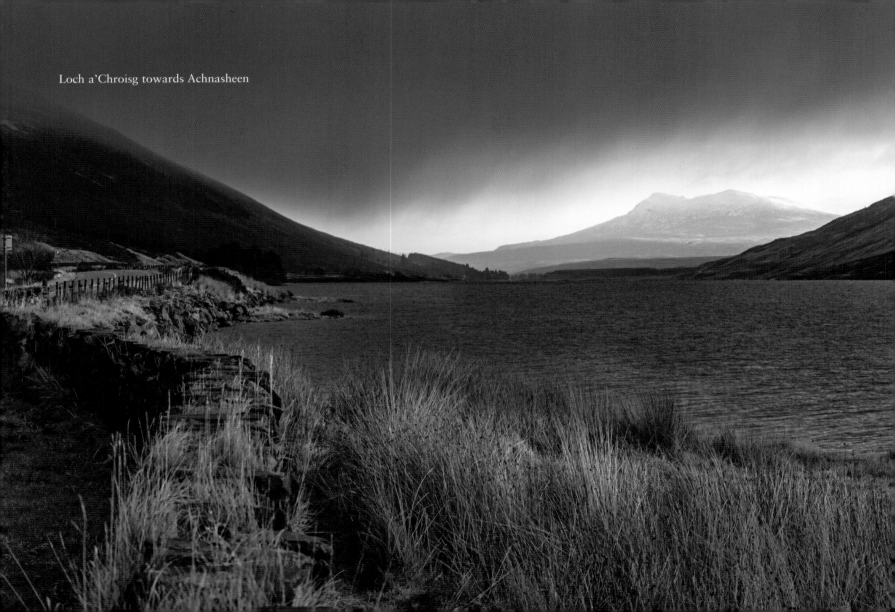

Loch a'Chroisg towards Achnasheen

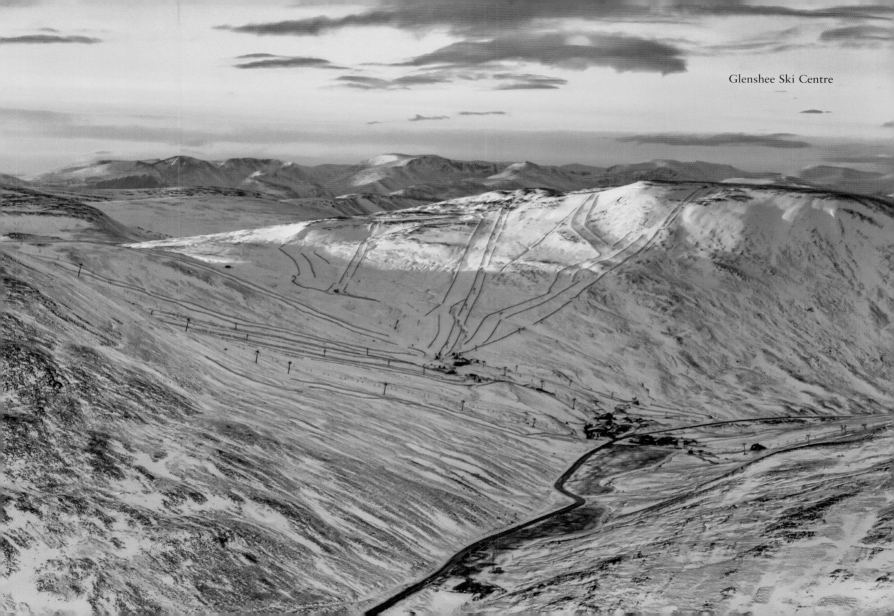

Glenshee Ski Centre

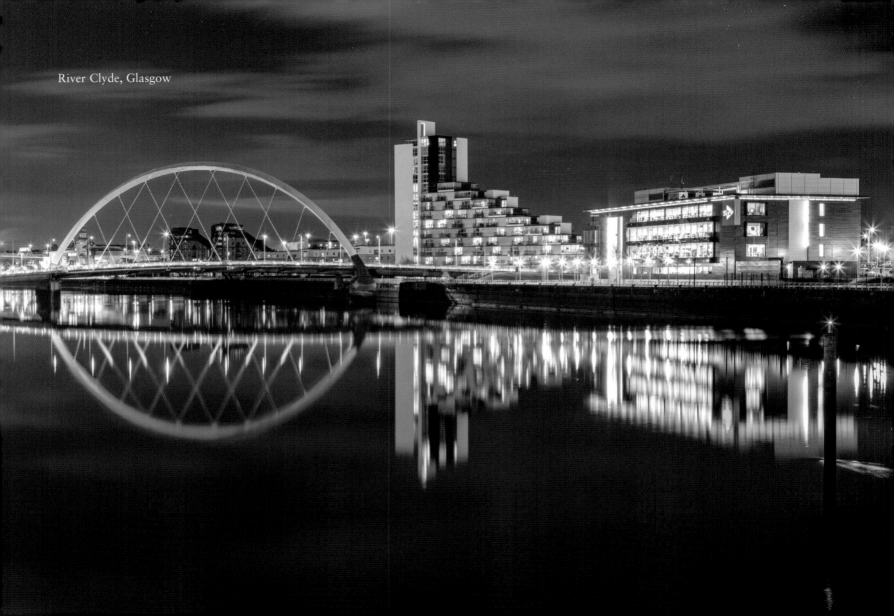
River Clyde, Glasgow

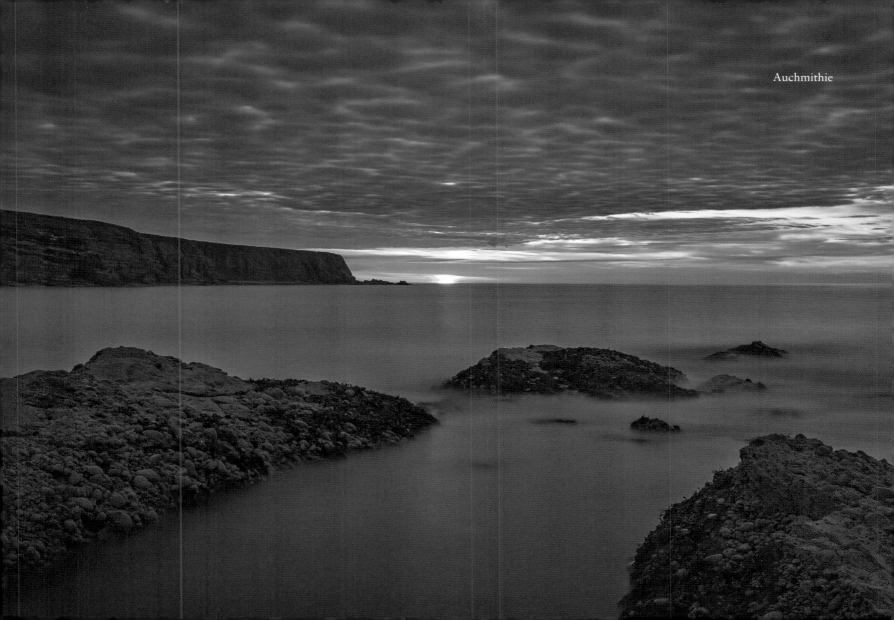

Auchmithie

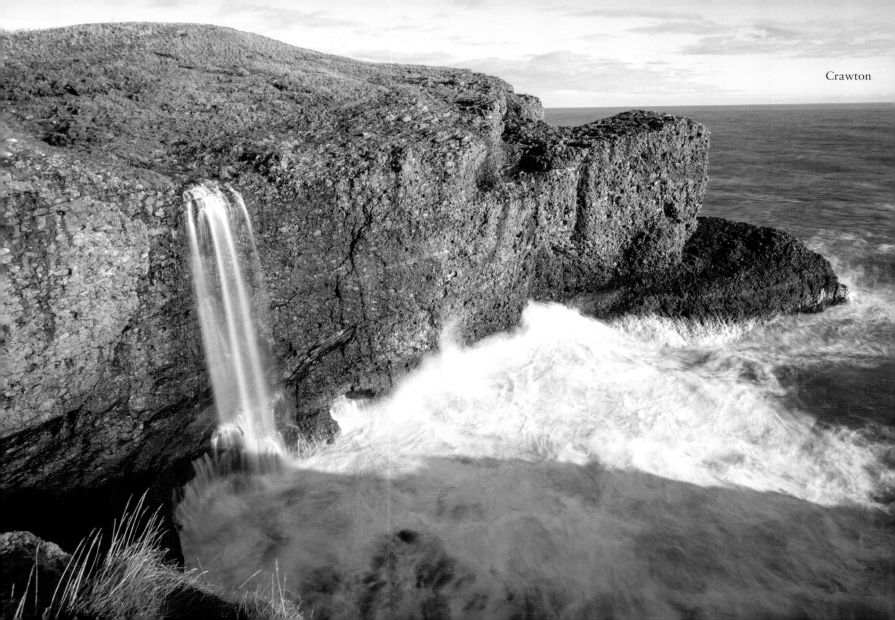

Crawton

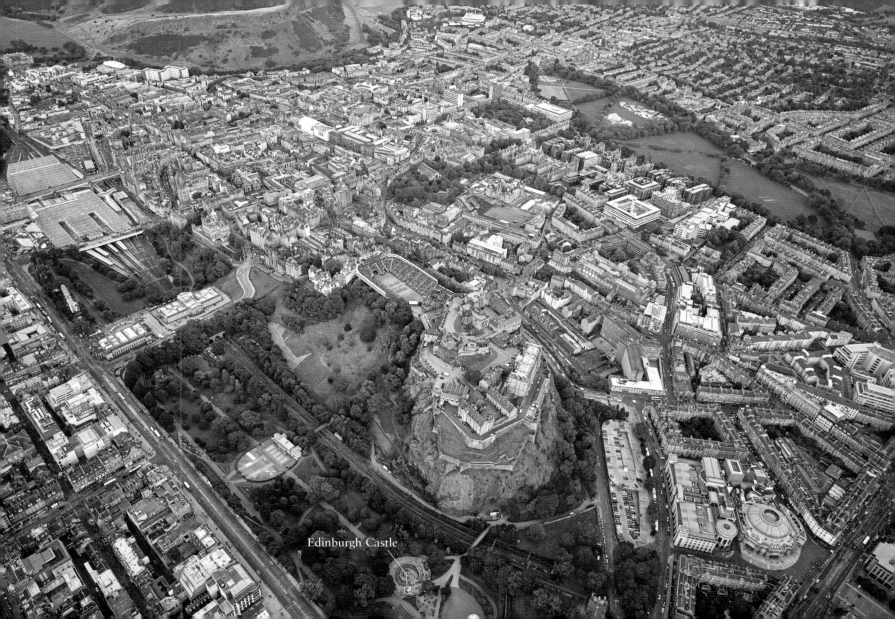

Edinburgh Castle

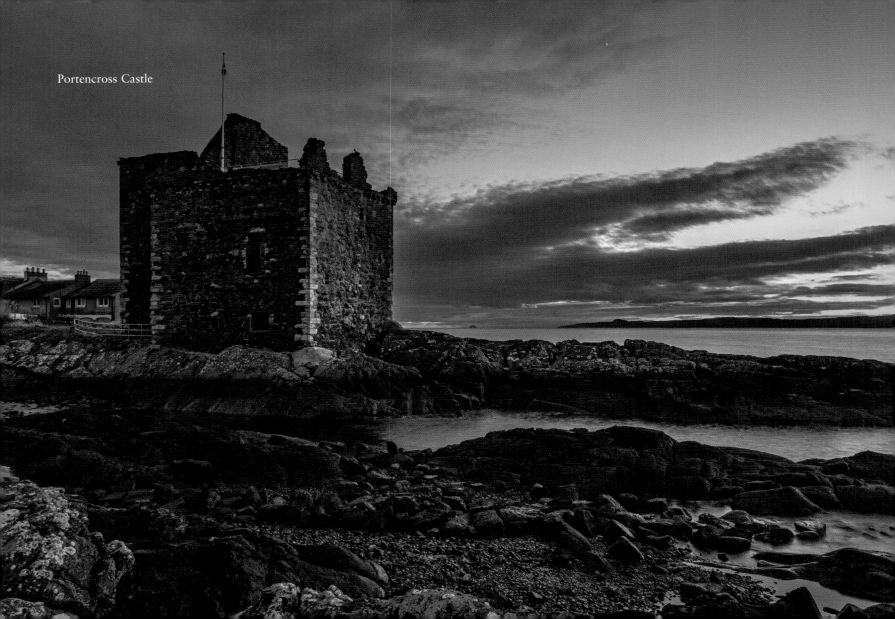

Portencross Castle

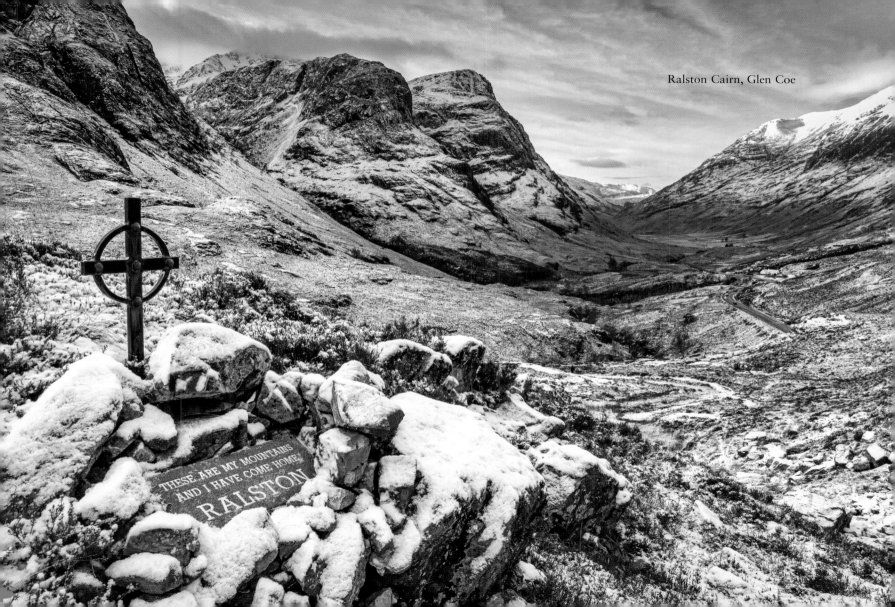

Ralston Cairn, Glen Coe

THESE ARE MY MOUNTAINS
AND I HAVE COME HOME
RALSTON

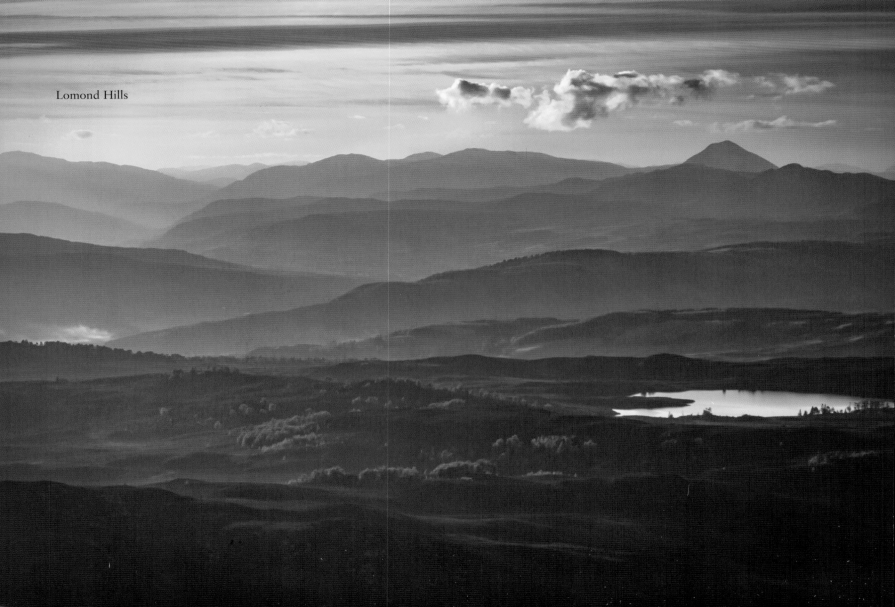

Lomond Hills

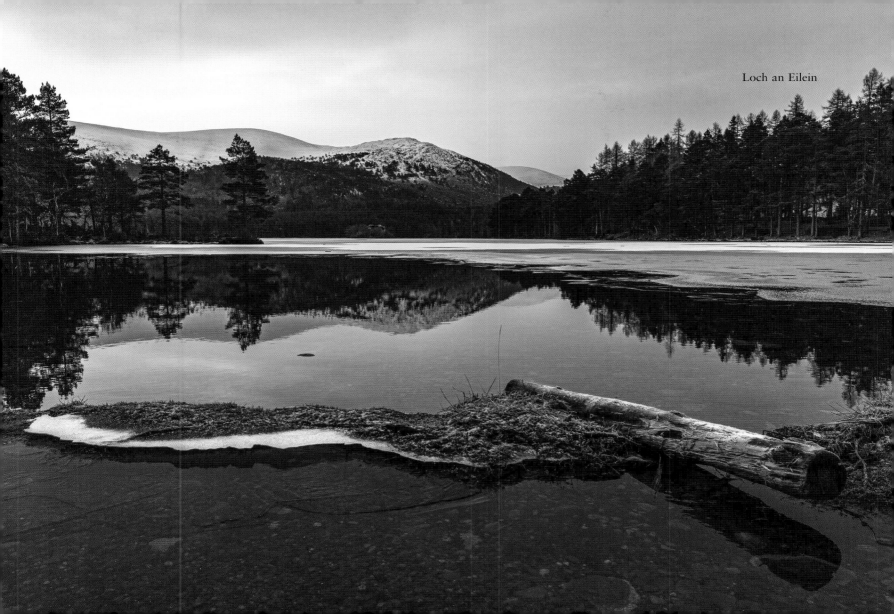

Loch an Eilein

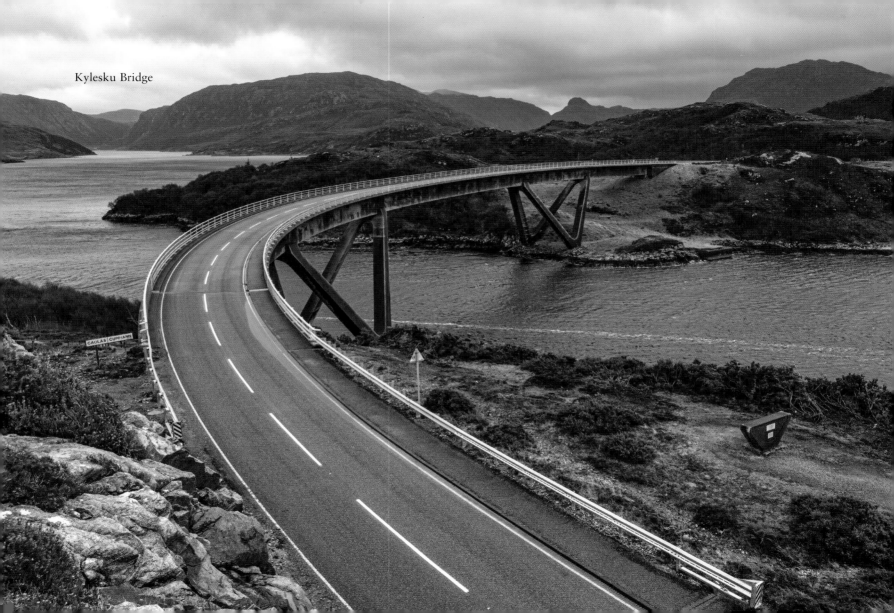

Kylesku Bridge

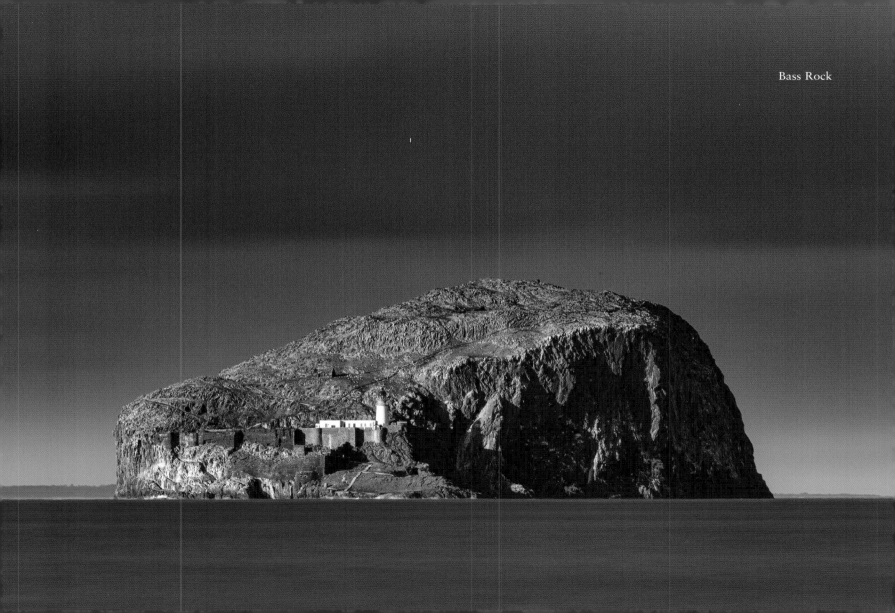

Bass Rock

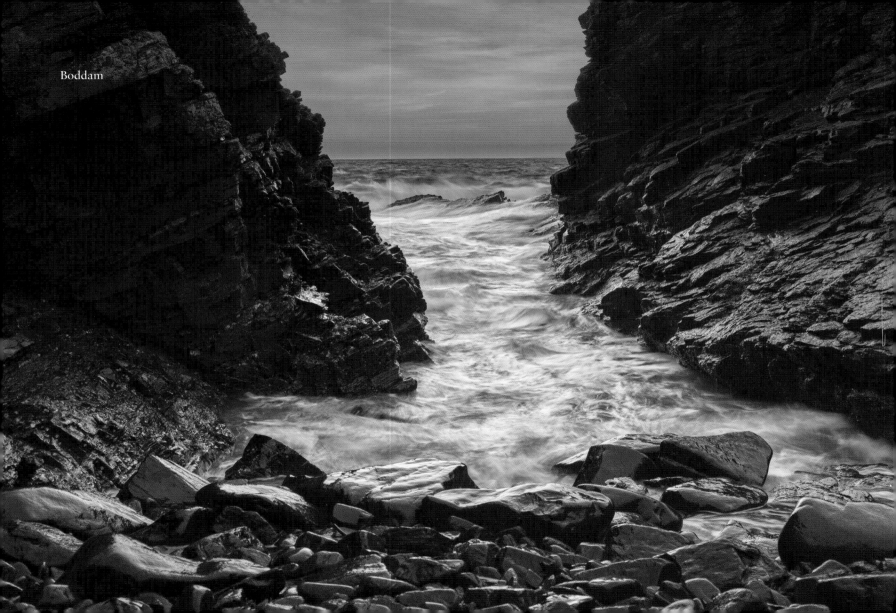

Boddam

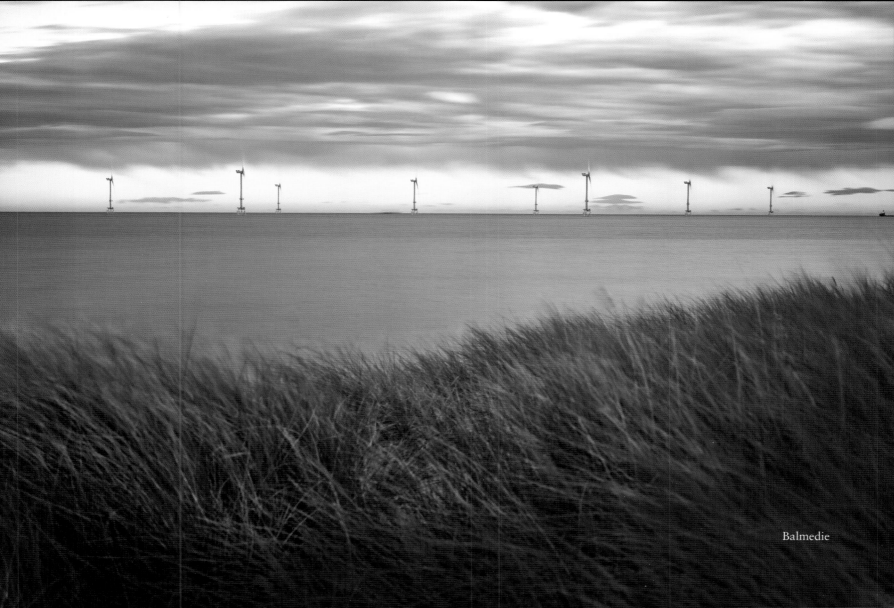

Balmedie

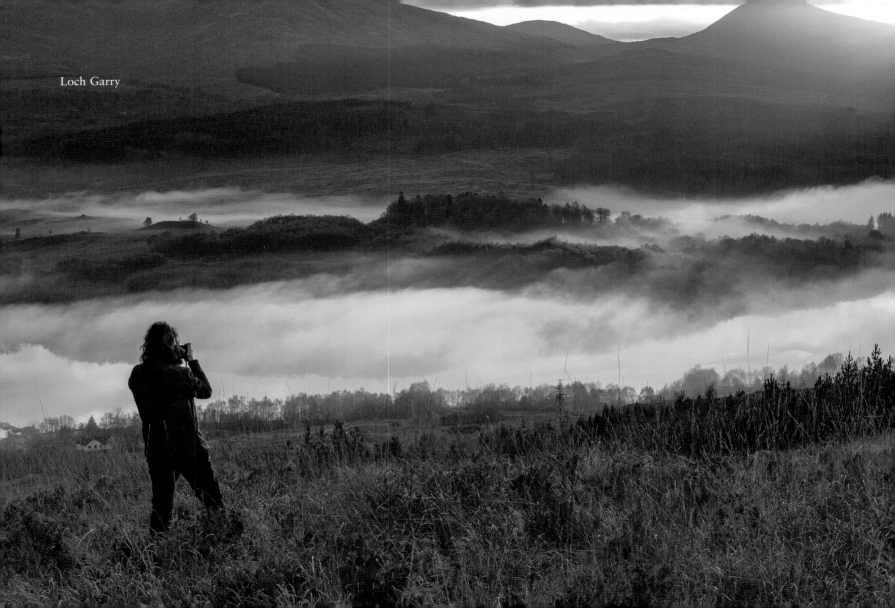

Loch Garry

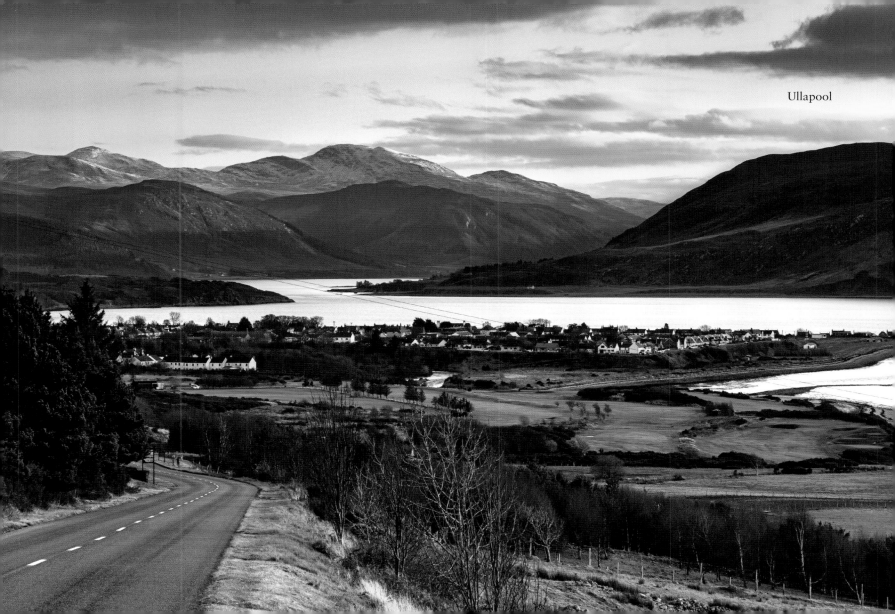

Ullapool

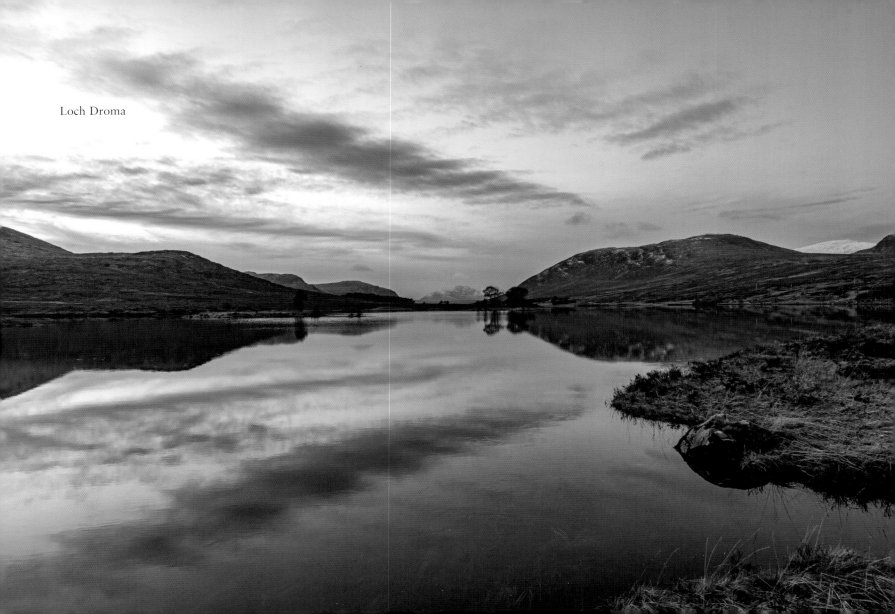

Loch Droma

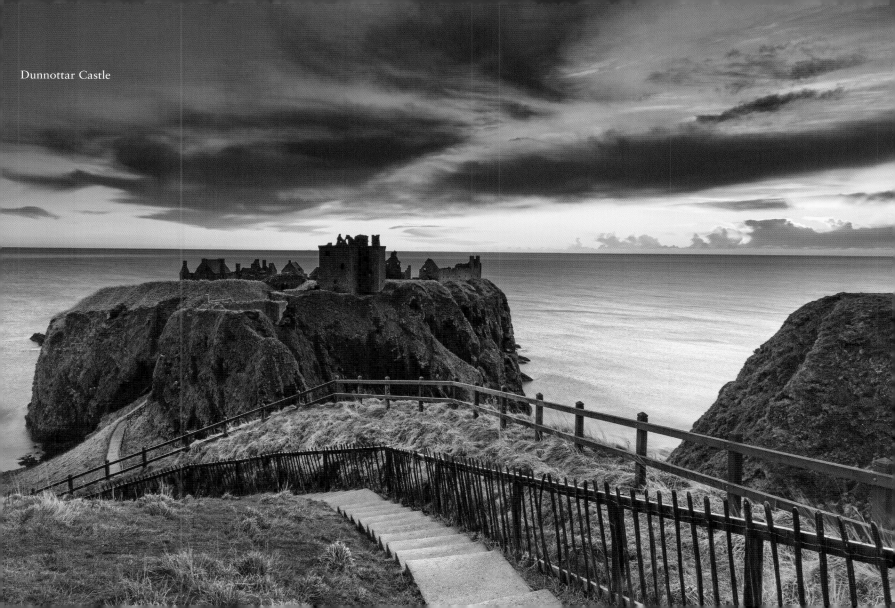

Dunnottar Castle

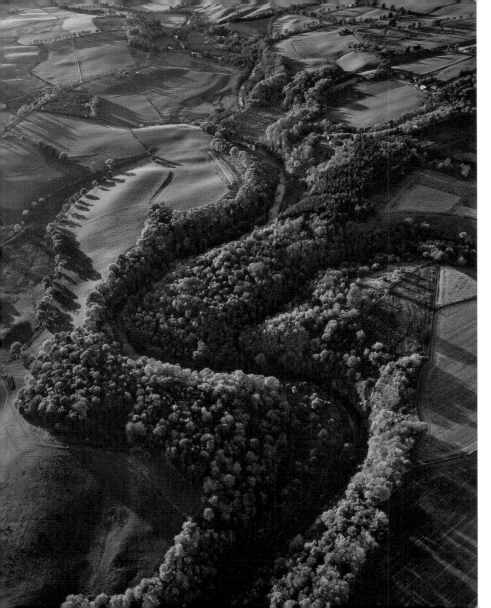

River Almond, Chapelhill

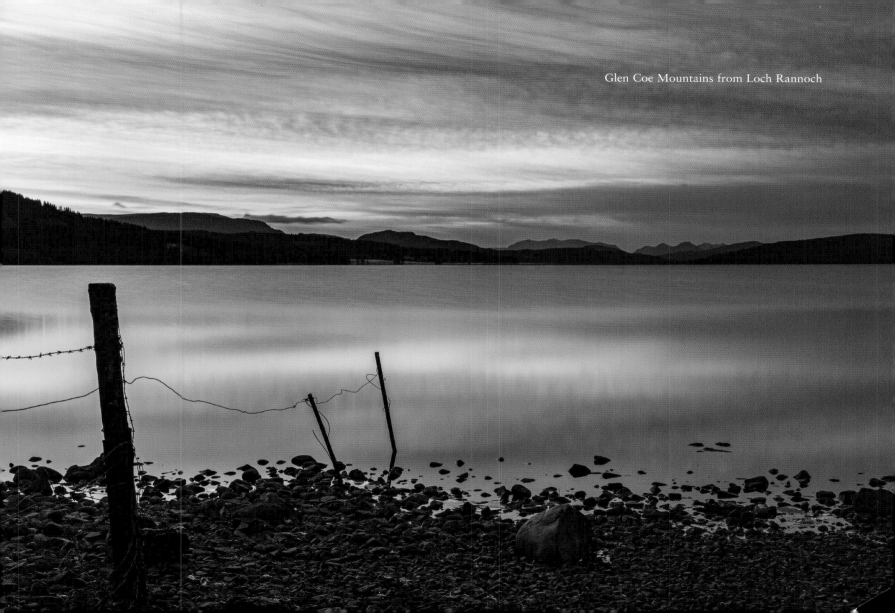

Glen Coe Mountains from Loch Rannoch

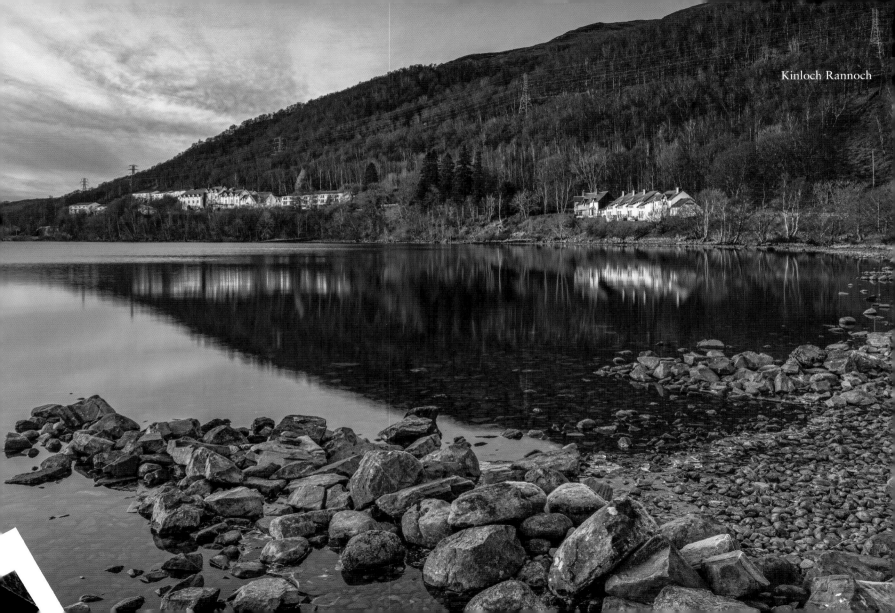
Kinloch Rannoch

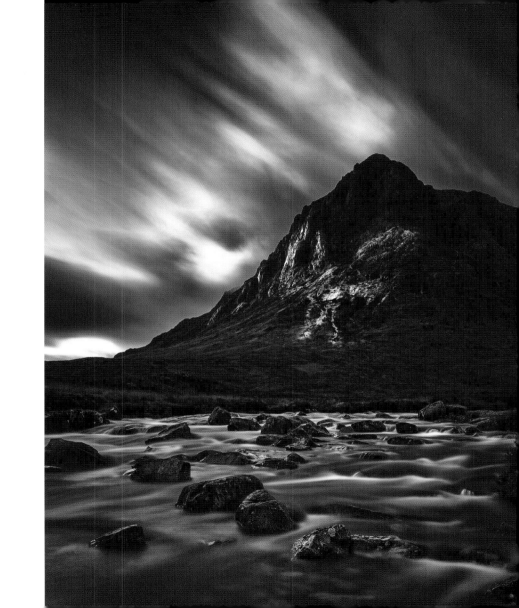

River Coupall, Glen Coe

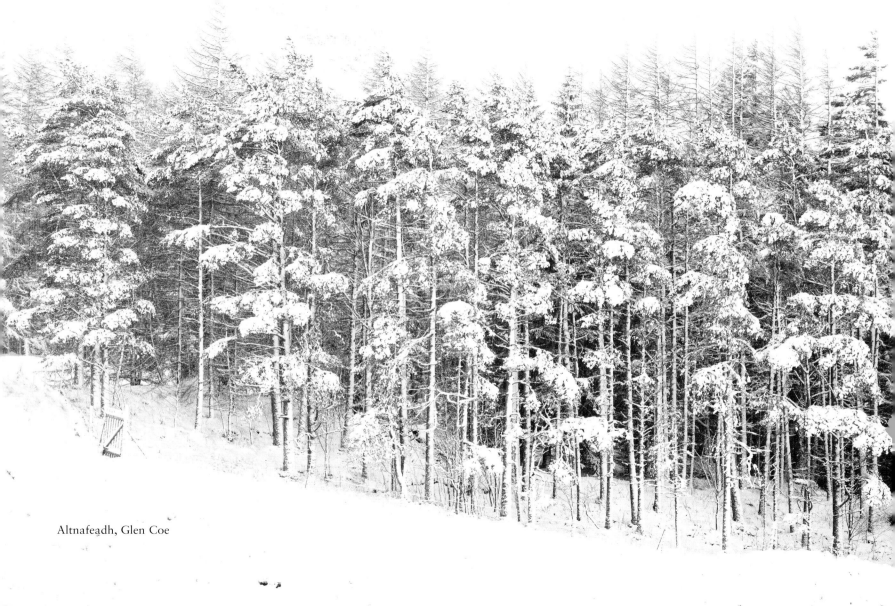

Altnafeadh, Glen Coe

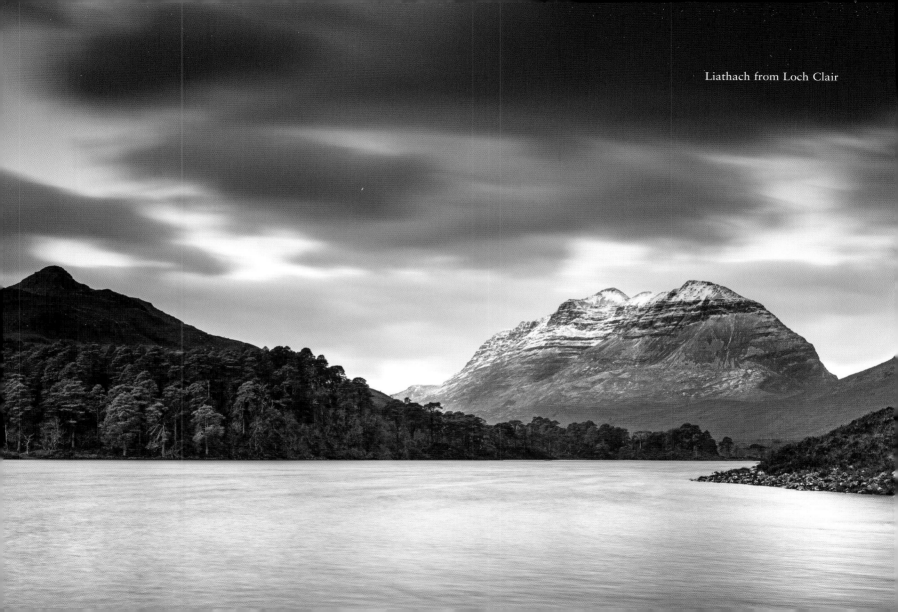

Liathach from Loch Clair

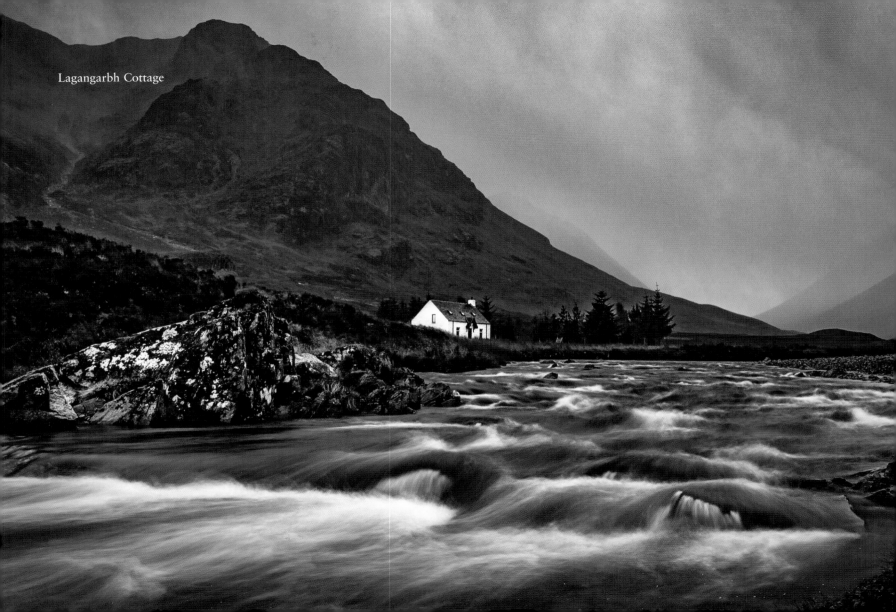

Lagangarbh Cottage

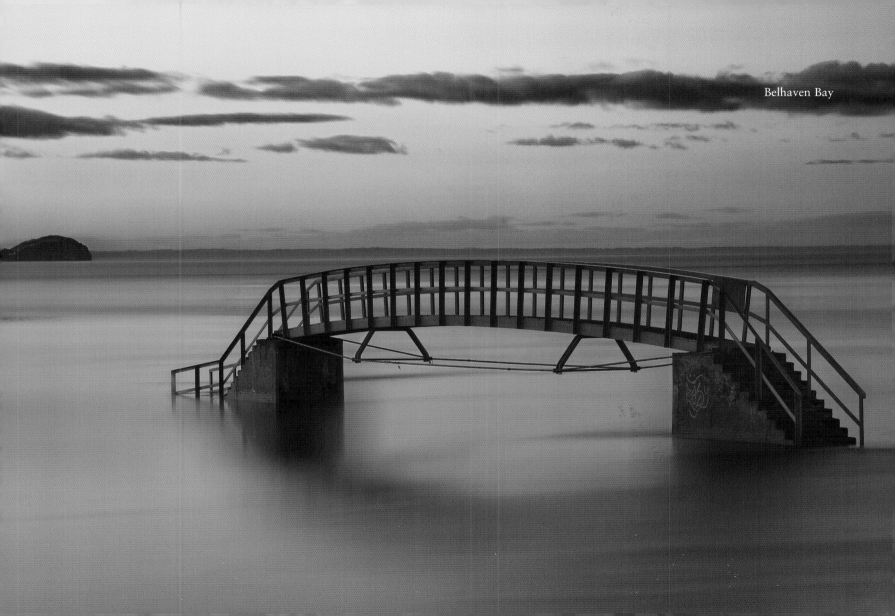

Belhaven Bay

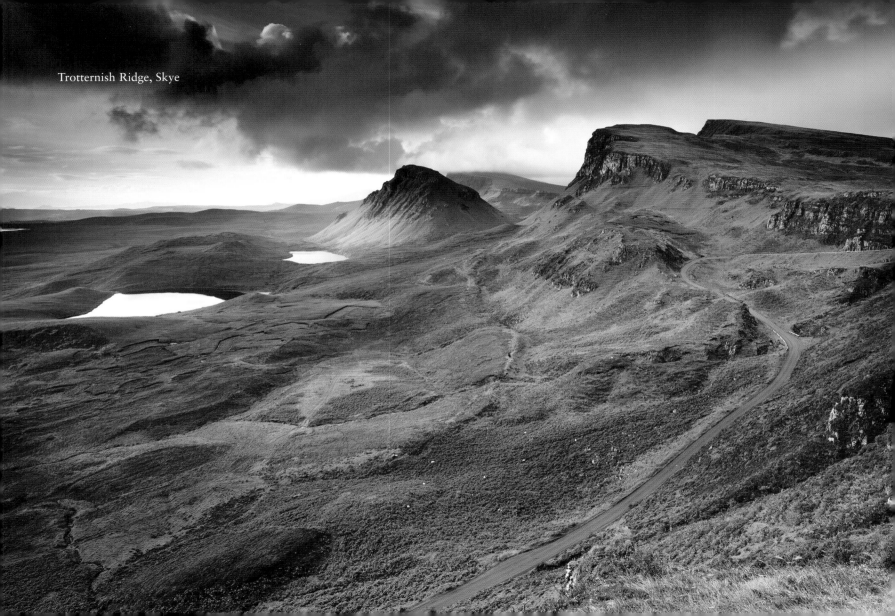
Trotternish Ridge, Skye

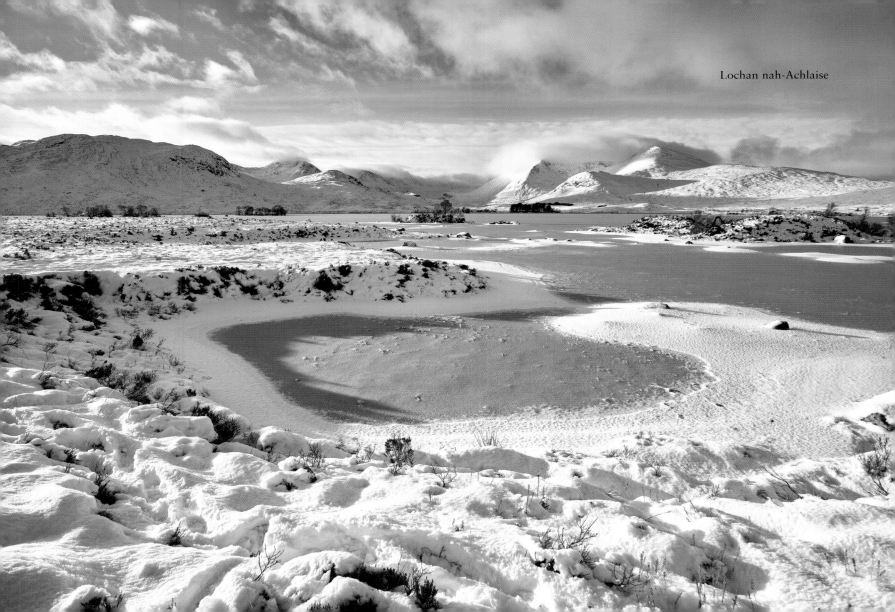

Lochan nah-Achlaise

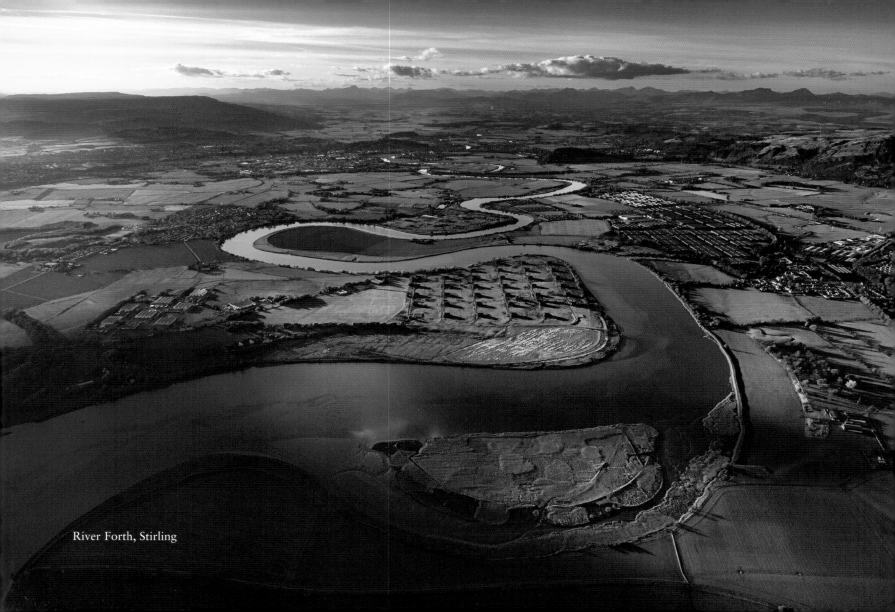

River Forth, Stirling

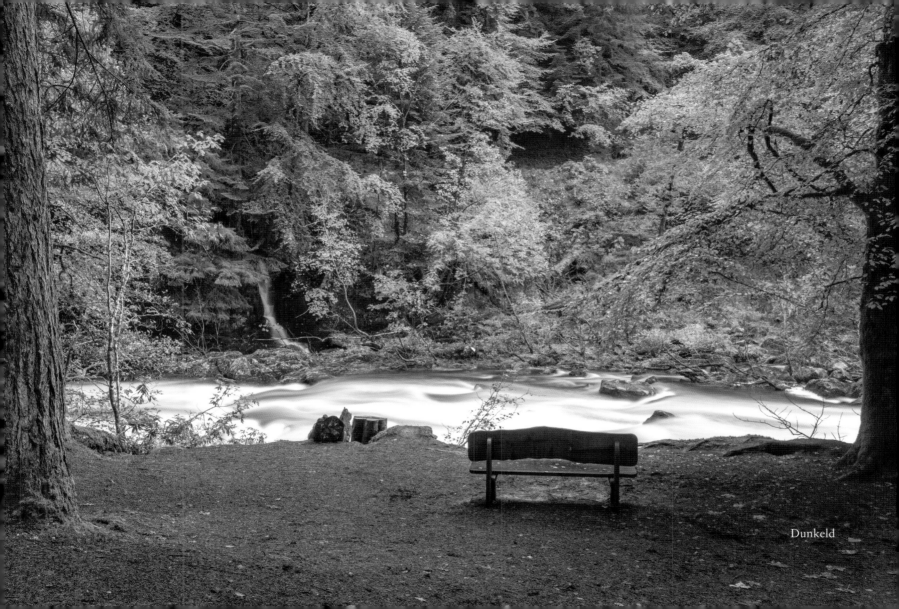

Dunkeld

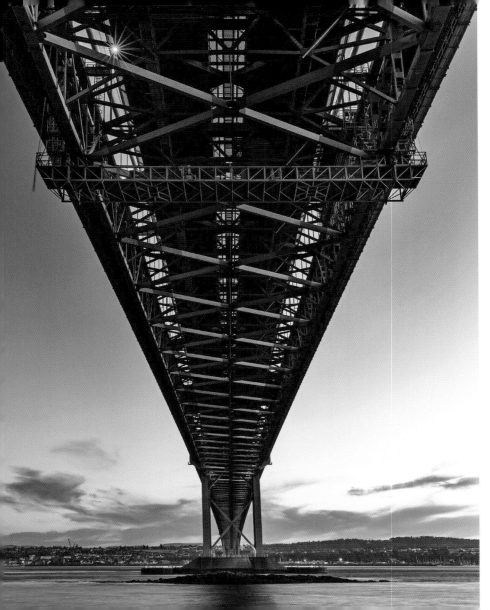

Forth Road Bridge

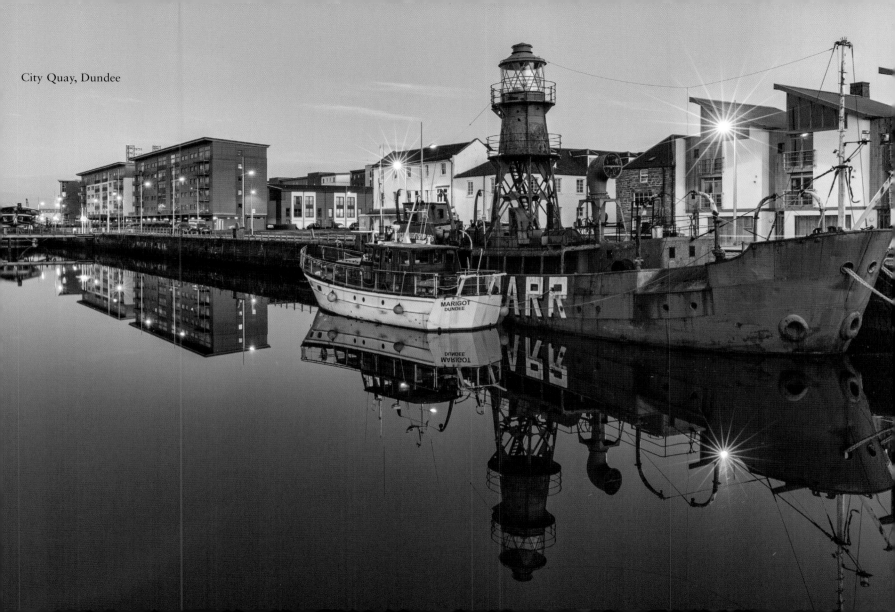

City Quay, Dundee

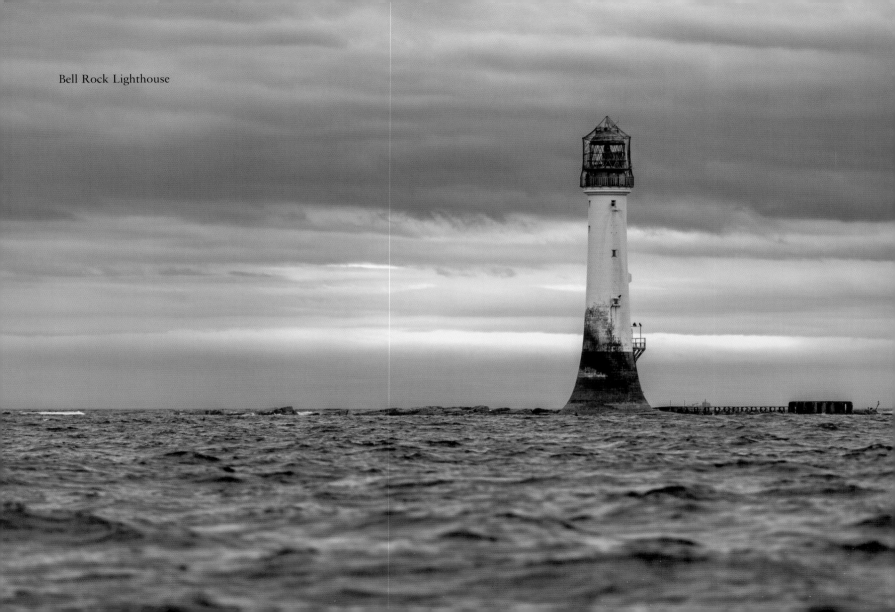

Bell Rock Lighthouse

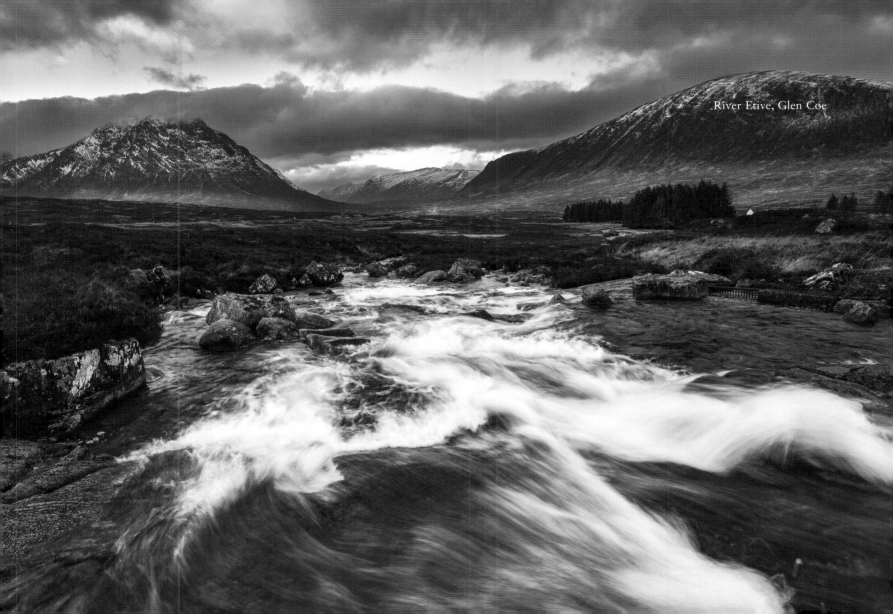

River Etive, Glen Coe

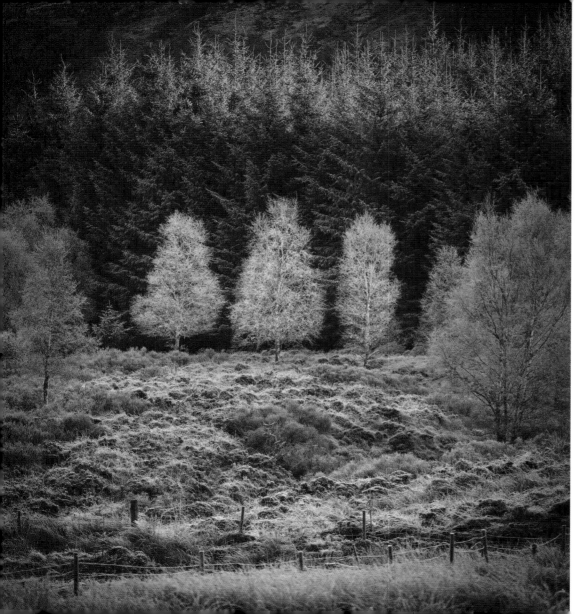

Glen Orchy

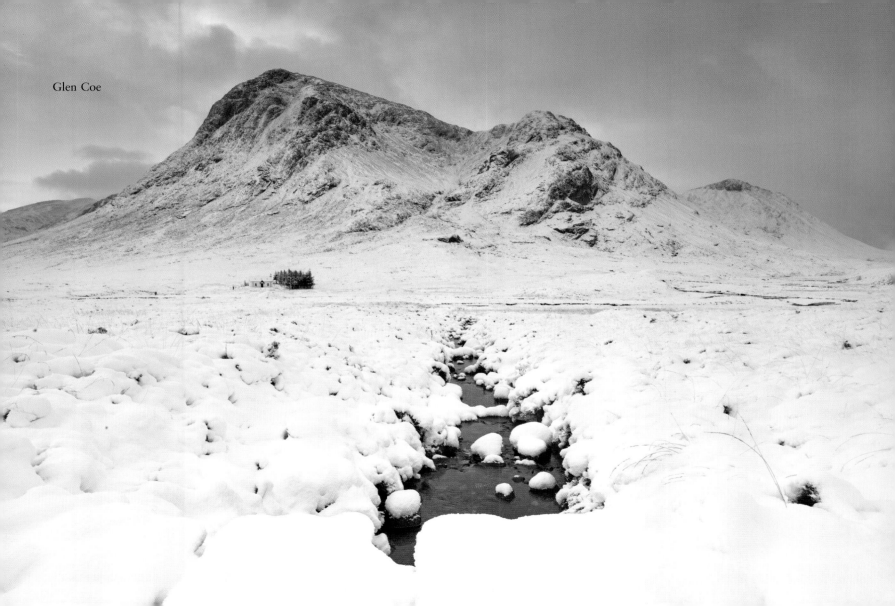

Glen Coe

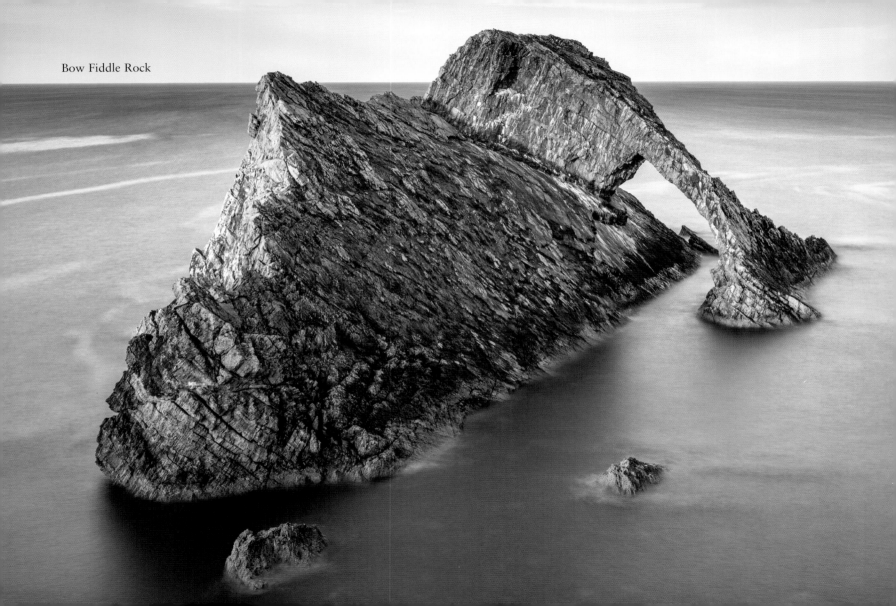

Bow Fiddle Rock

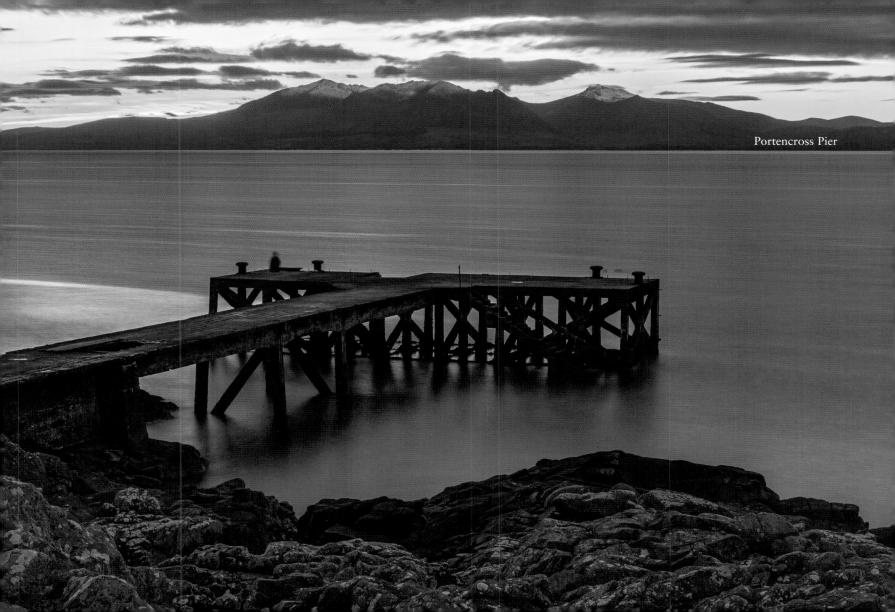

Portencross Pier

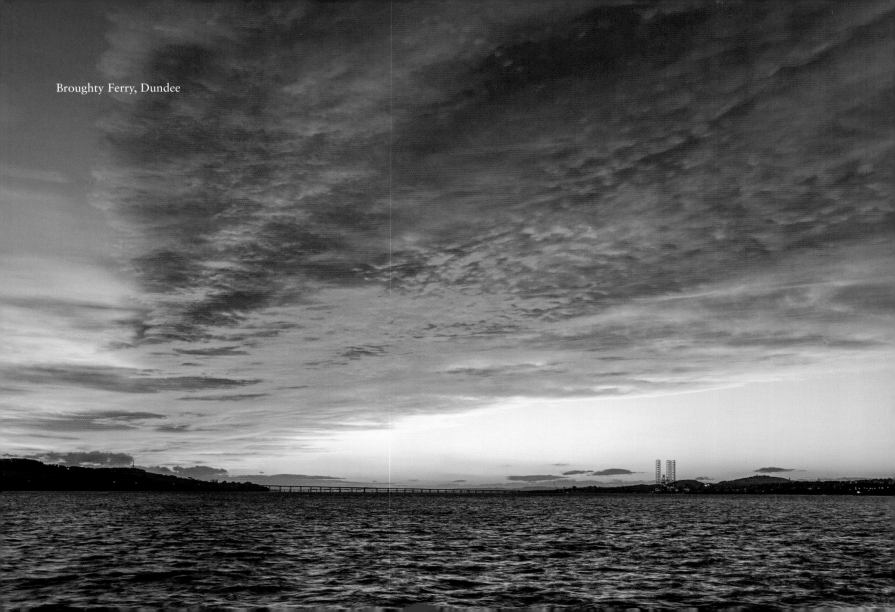

Broughty Ferry, Dundee

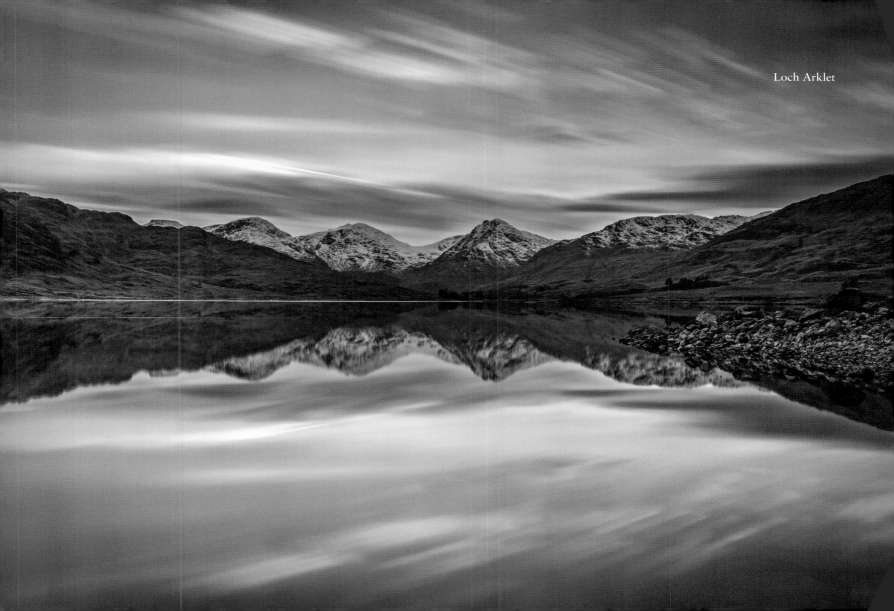

Loch Arklet

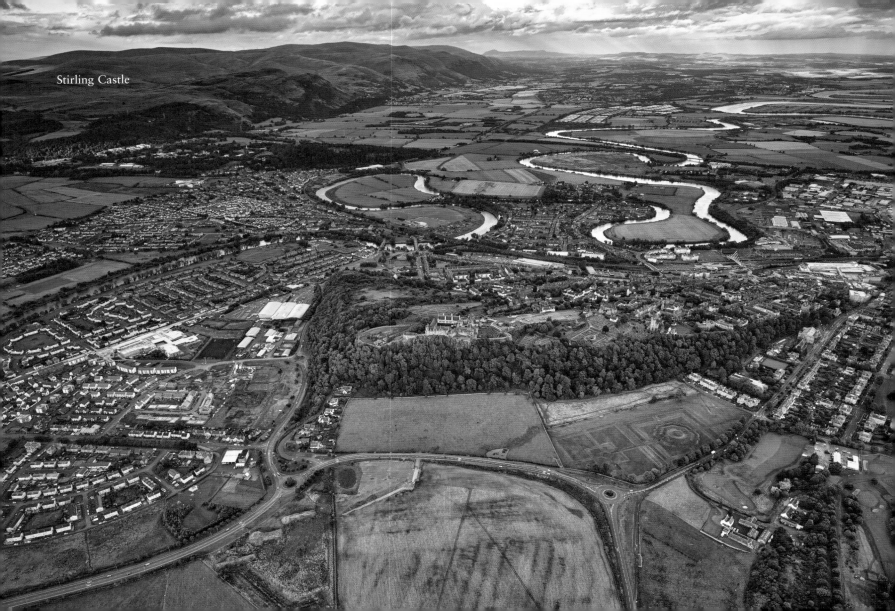

Stirling Castle

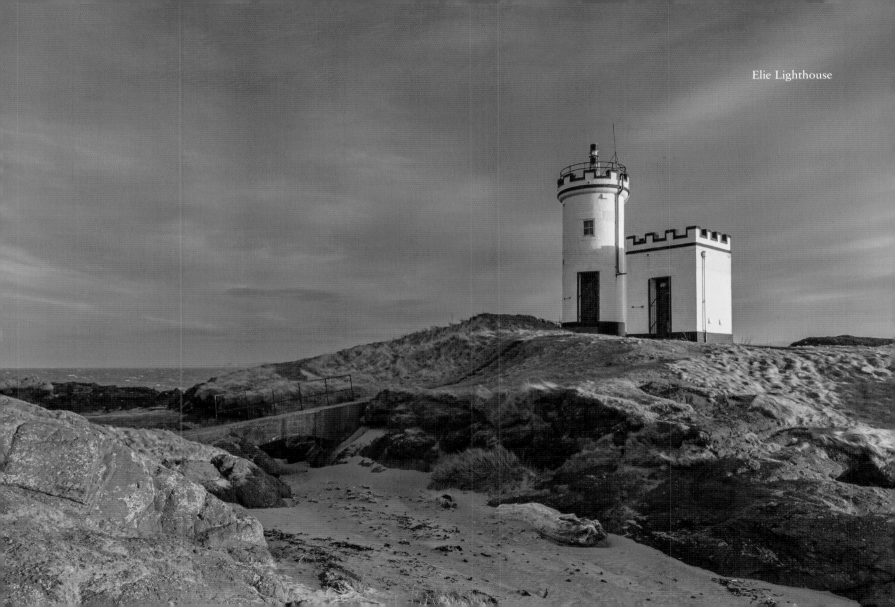
Elie Lighthouse

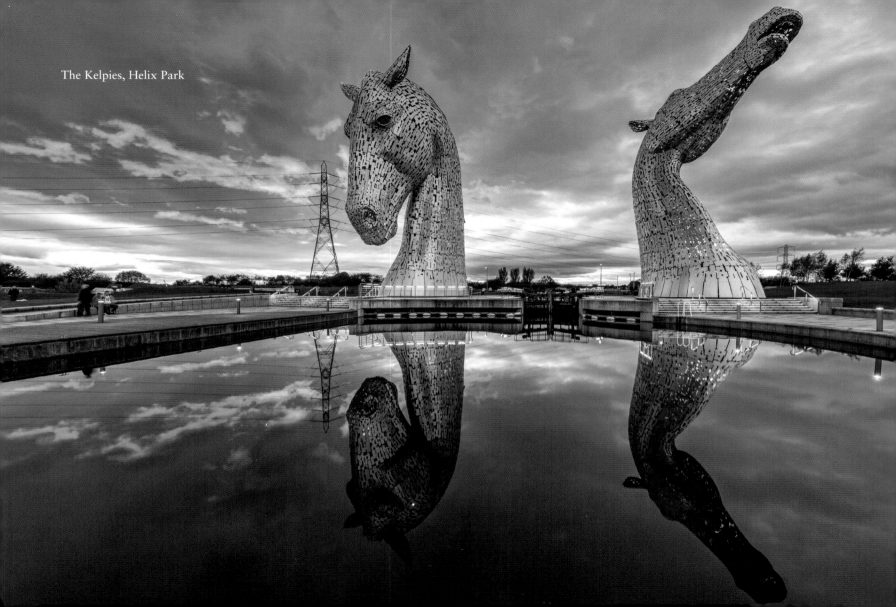

The Kelpies, Helix Park

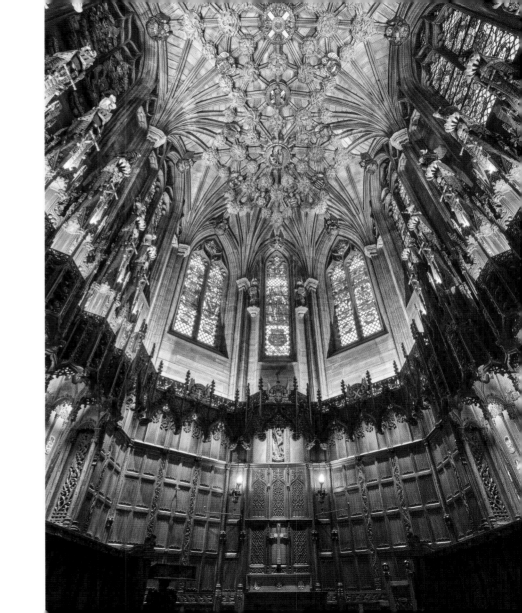

Thistle Chapel, St Giles Cathedral

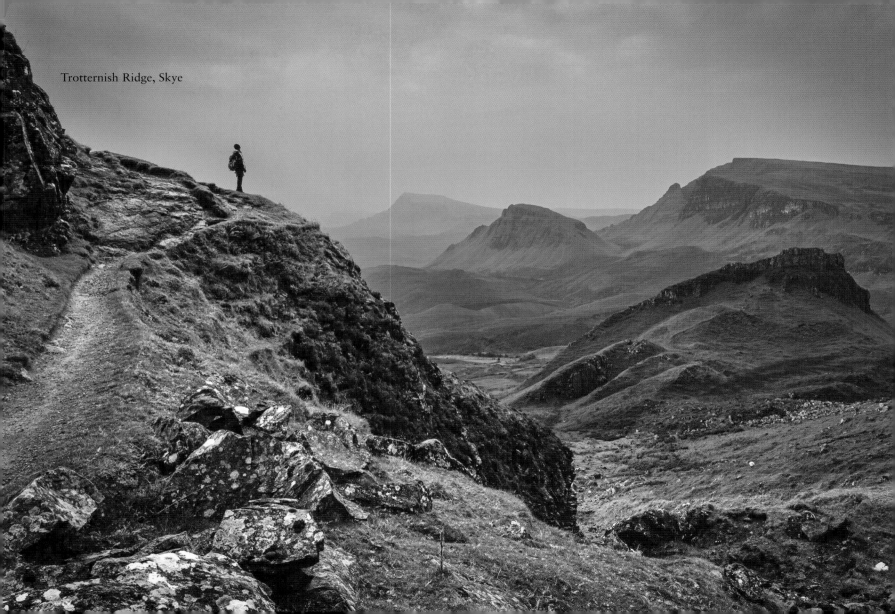

Trotternish Ridge, Skye

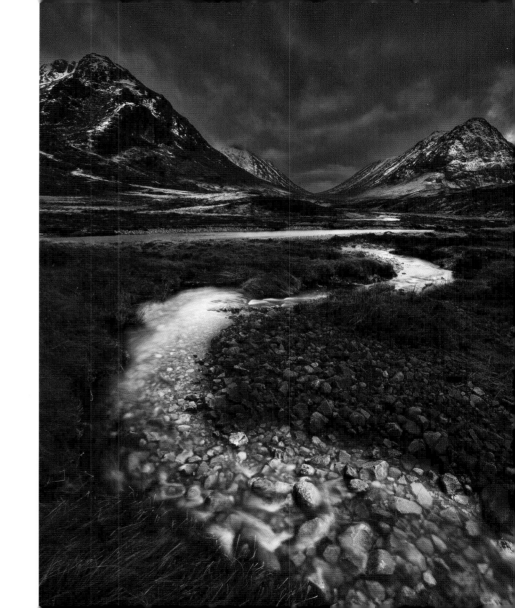

River Coupall, Glen Coe

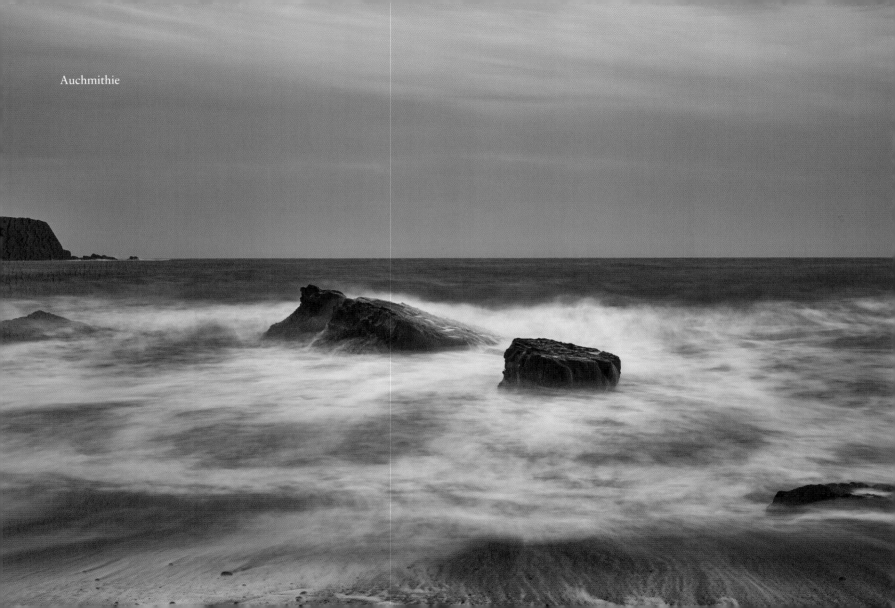

Auchmithie

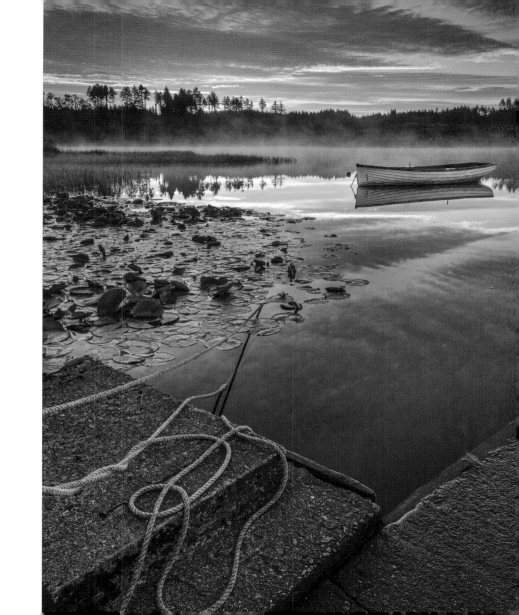

Loch Rusky

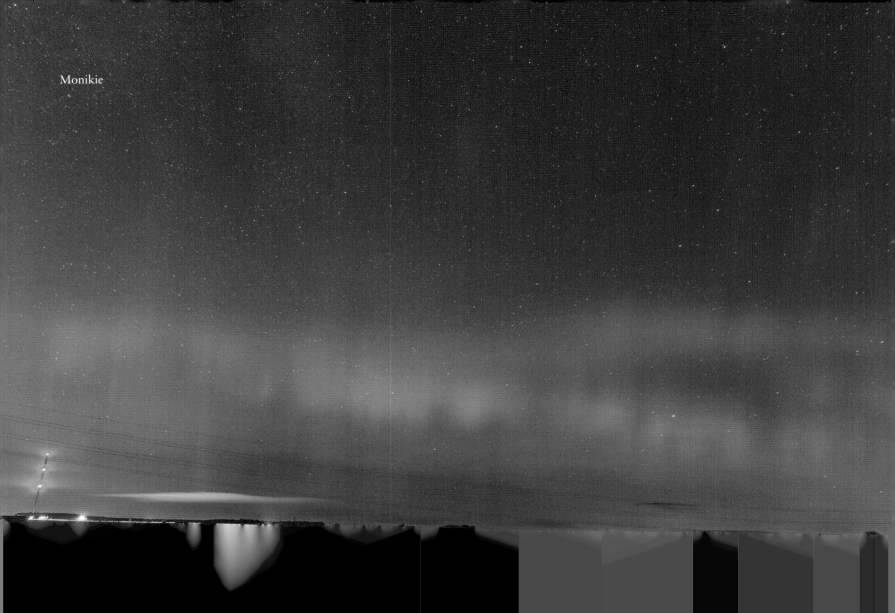

Monikie

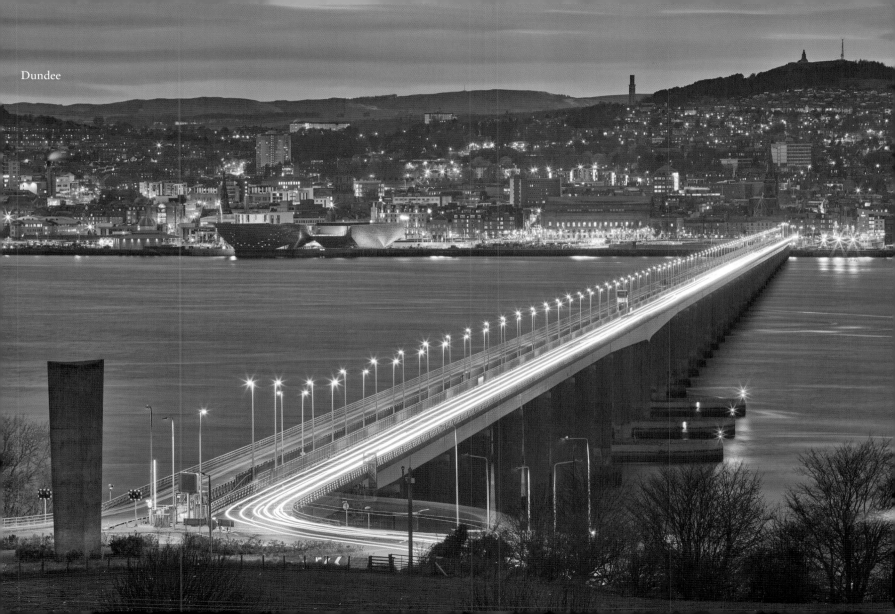

Dundee

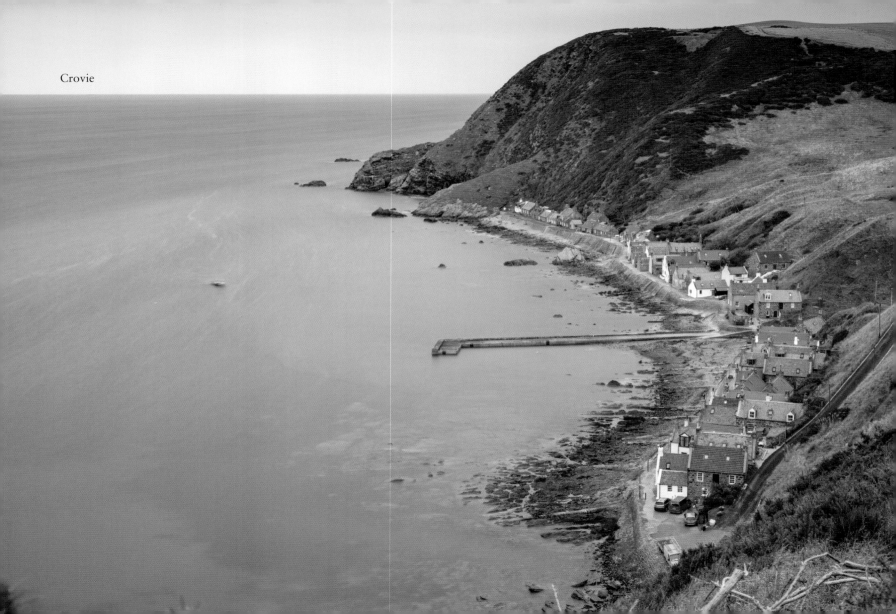

Crovie

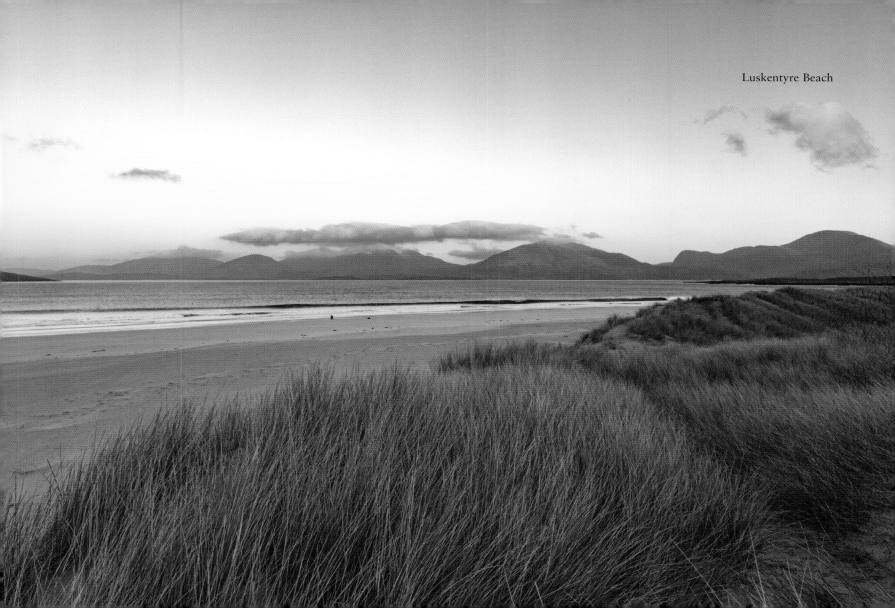
Luskentyre Beach

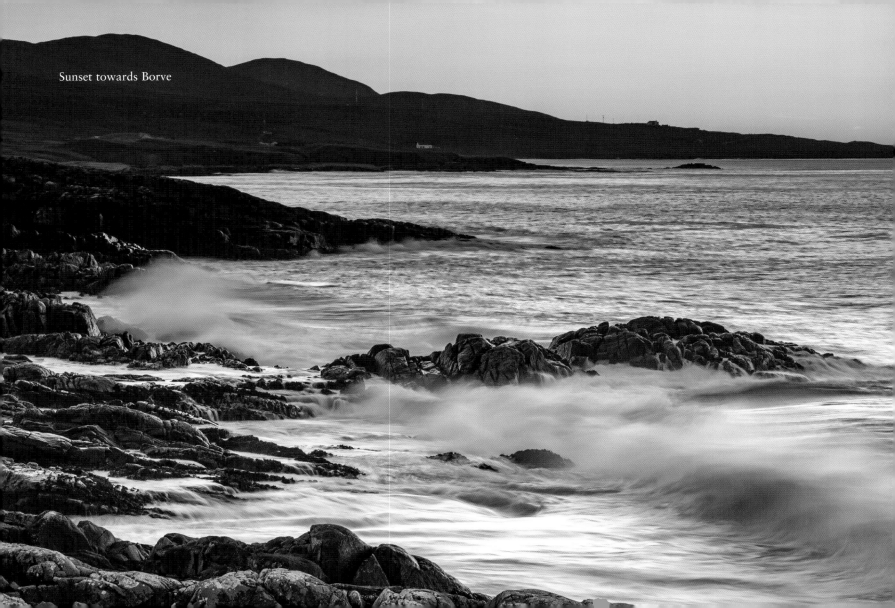

Sunset towards Borve

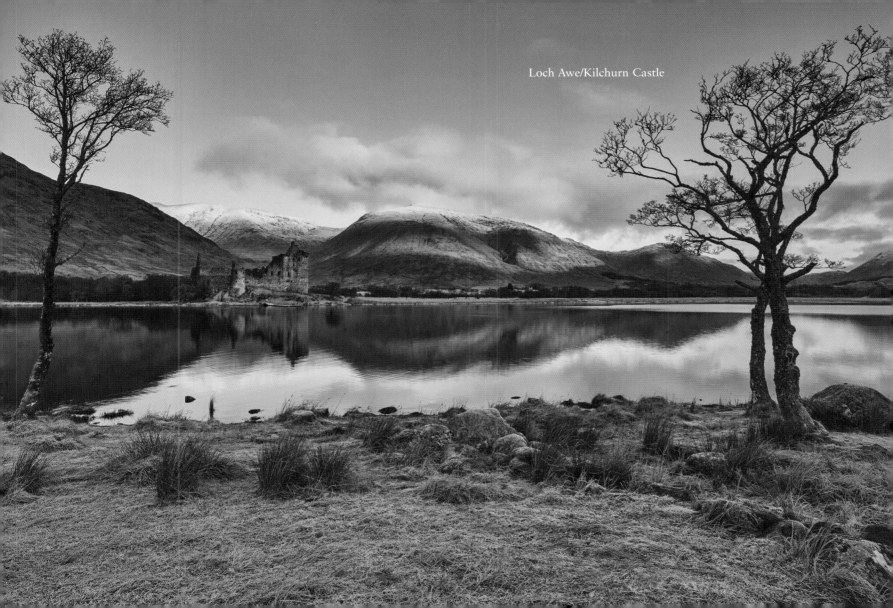
Loch Awe/Kilchurn Castle

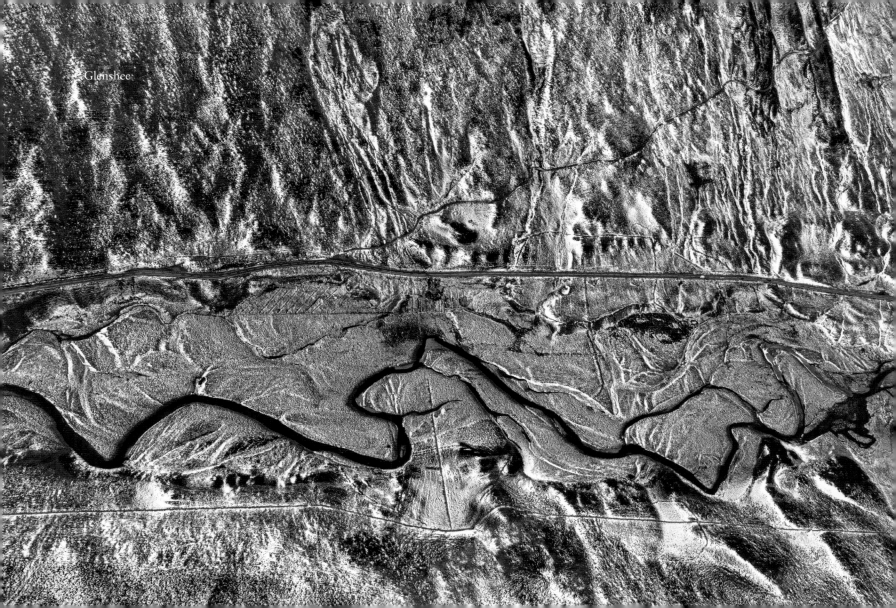

Glenshee

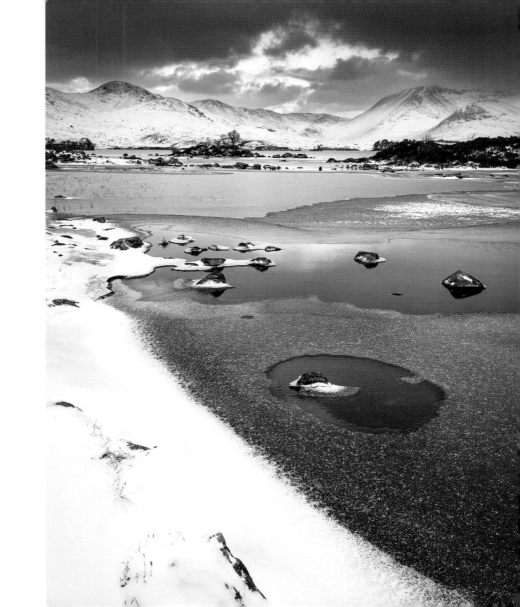

Lochan nah-Achlaise

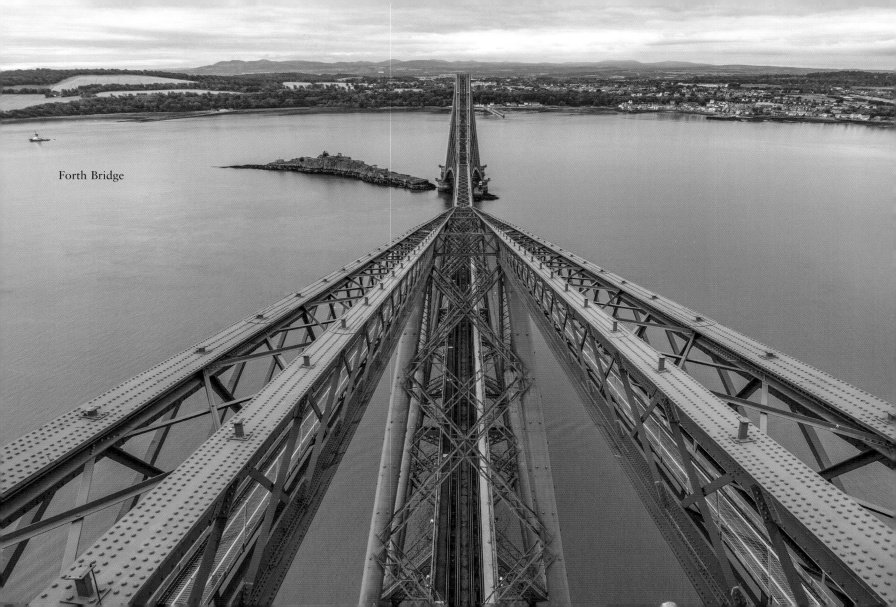

Forth Bridge

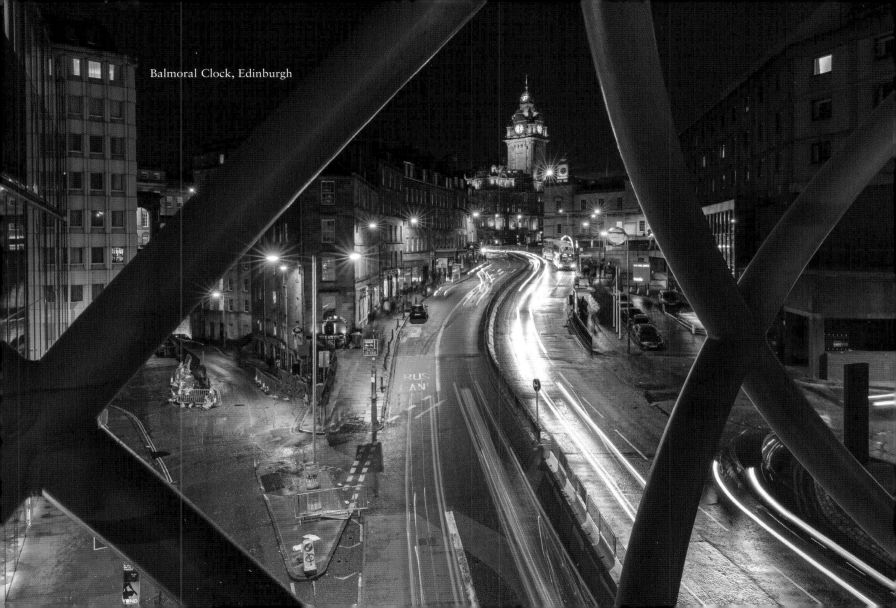

Balmoral Clock, Edinburgh

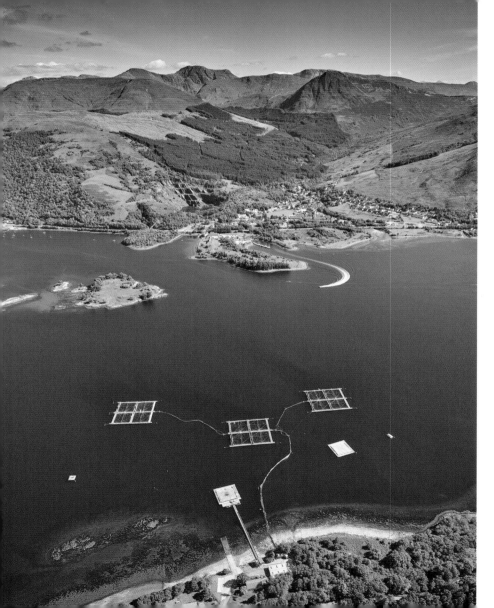

Ballachulish/Loch Leven

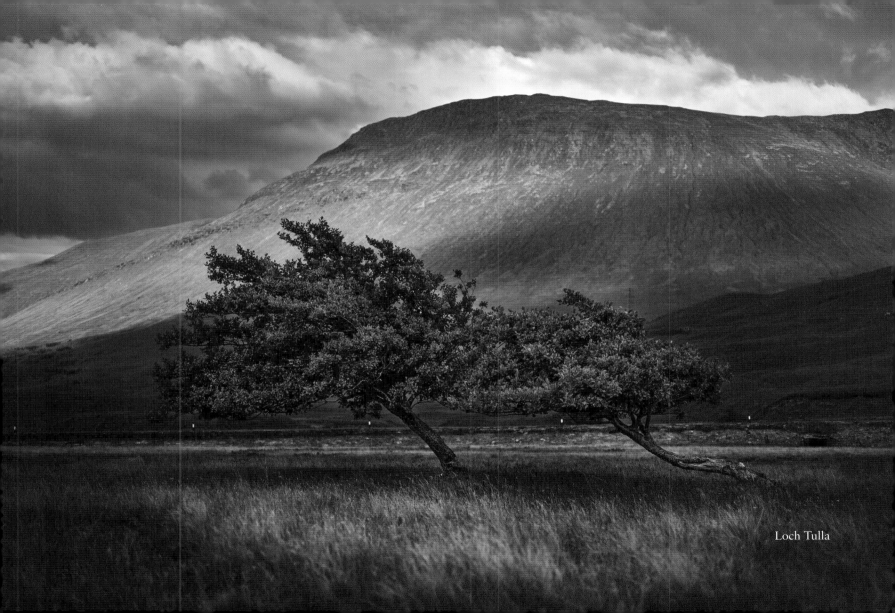

Loch Tulla

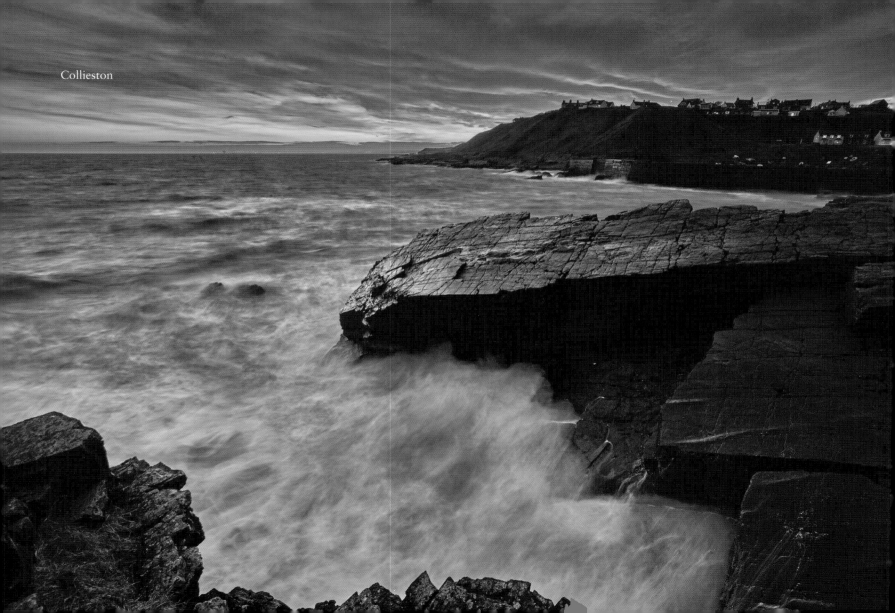

Collieston

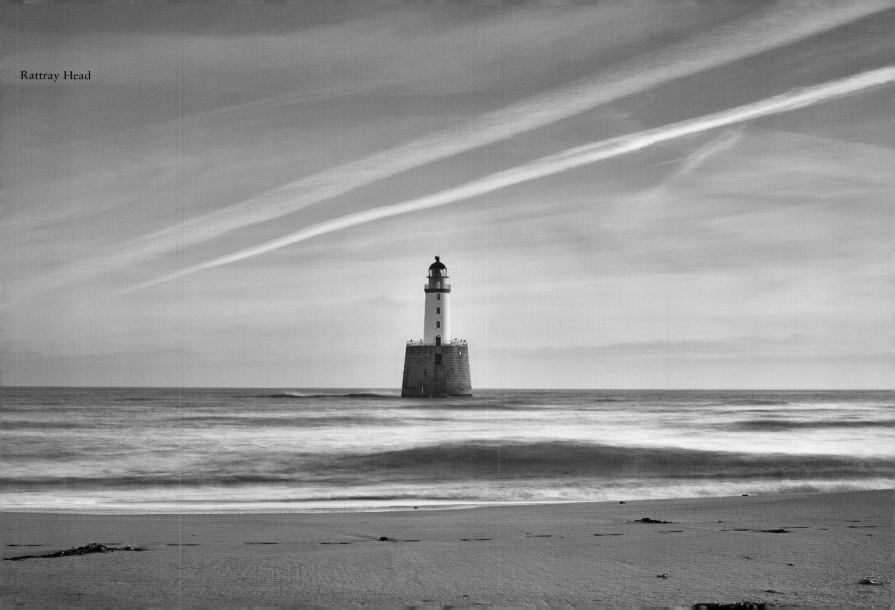

Rattray Head

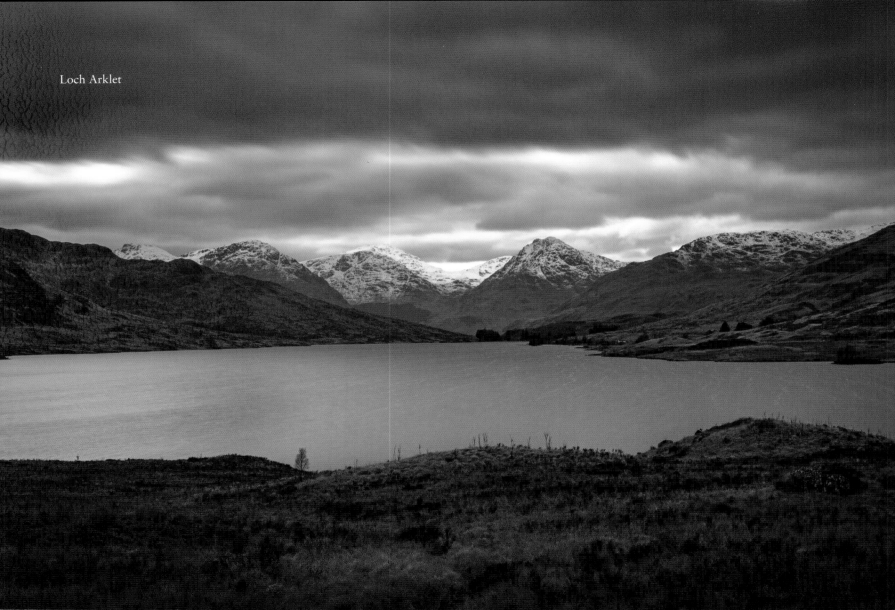

Loch Arklet

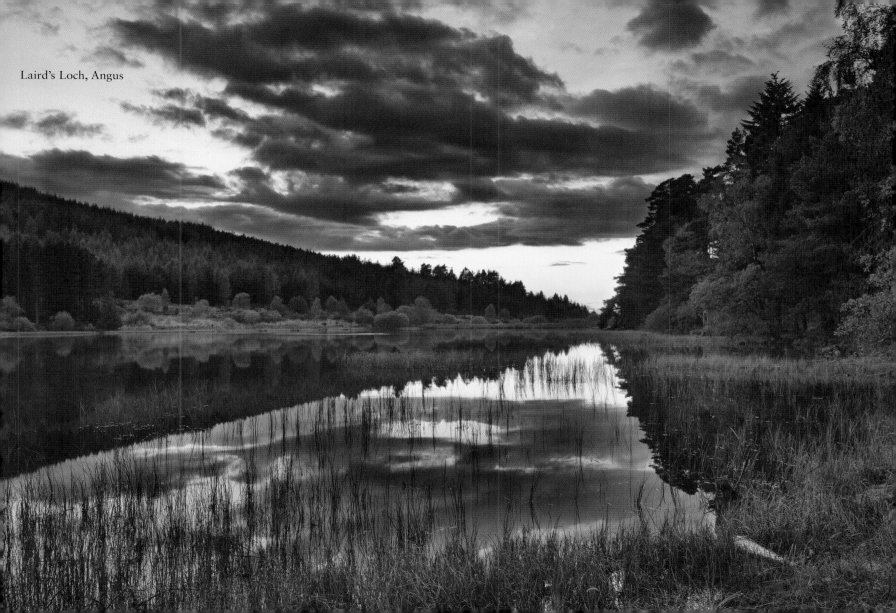

Laird's Loch, Angus

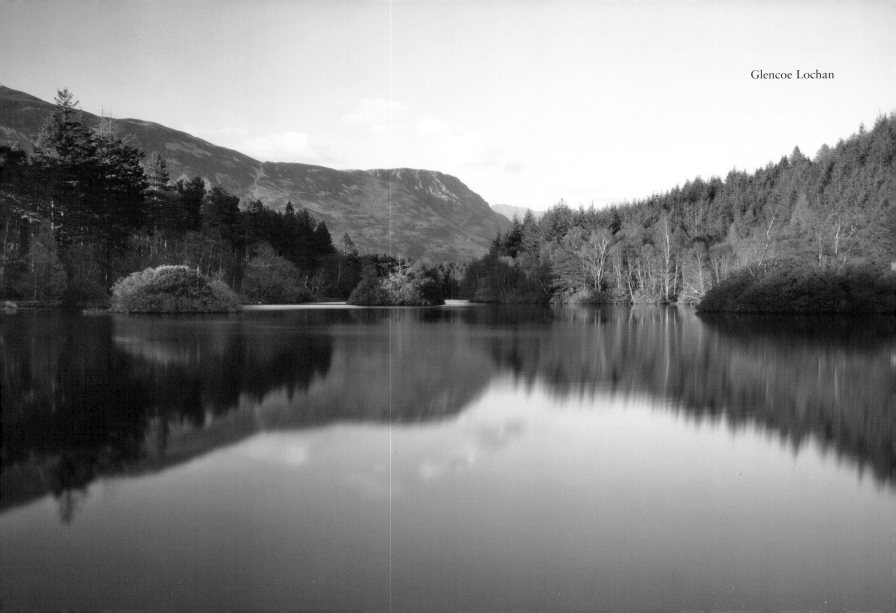

Glencoe Lochan

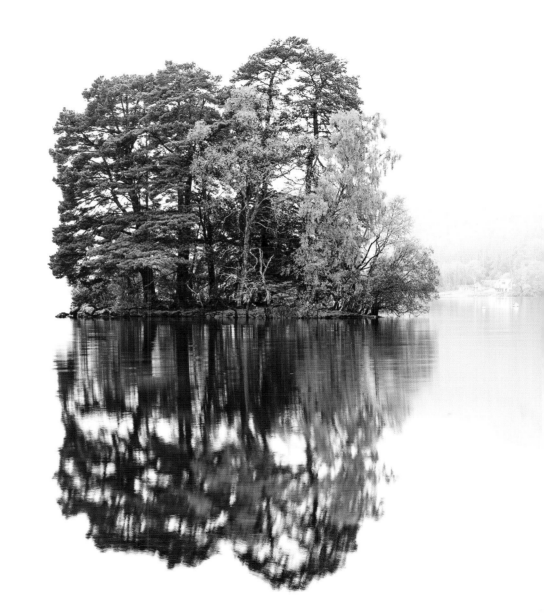

Kenmore

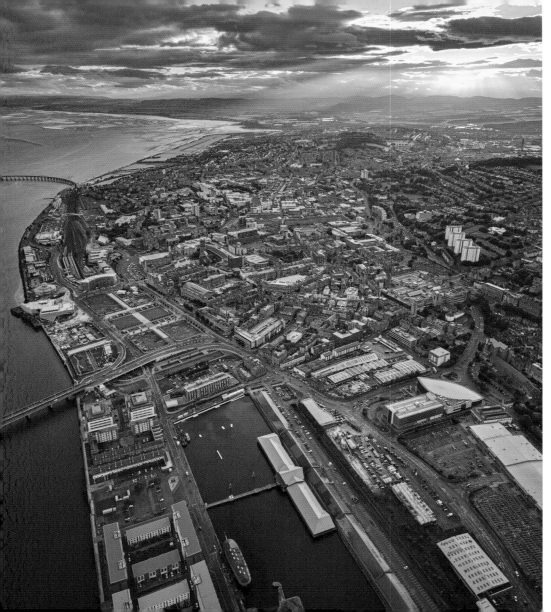

Dundee

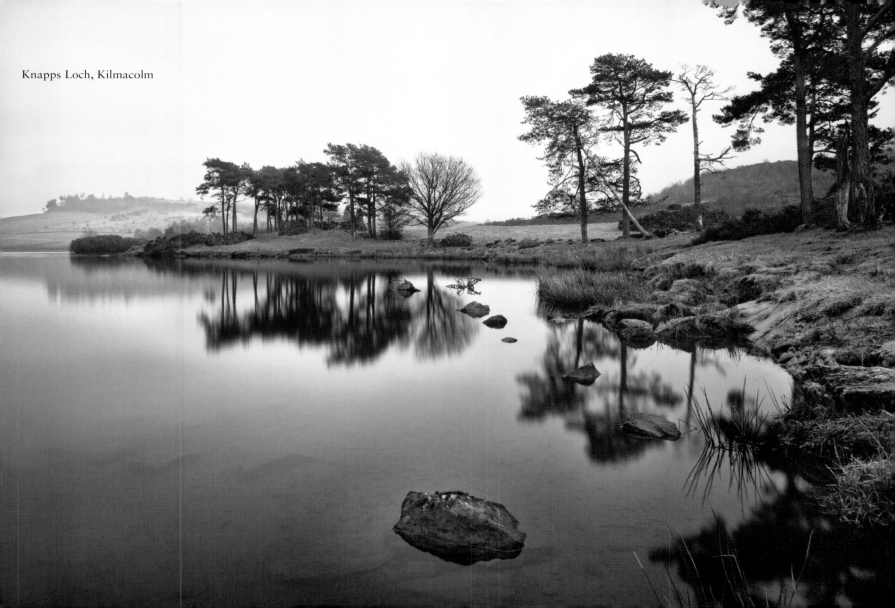

Knapps Loch, Kilmacolm

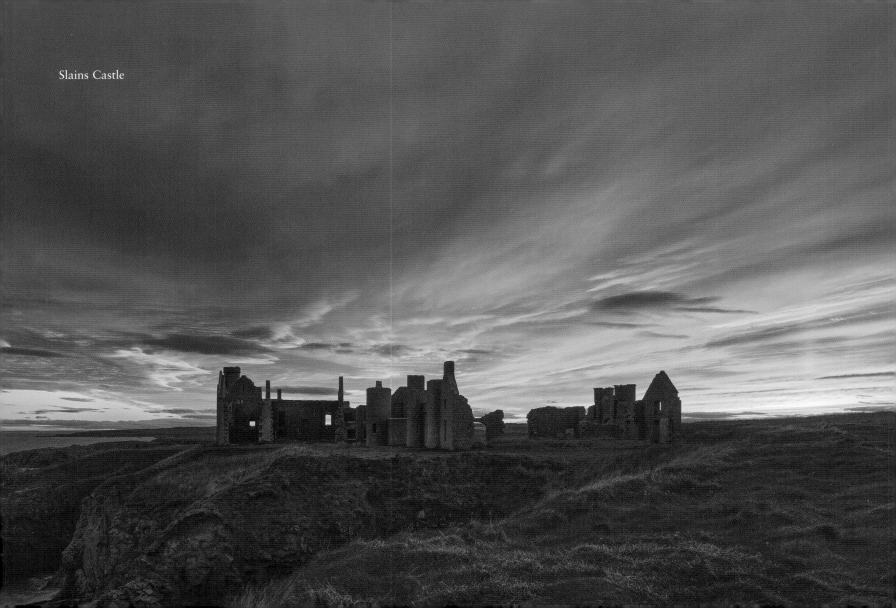

Slains Castle

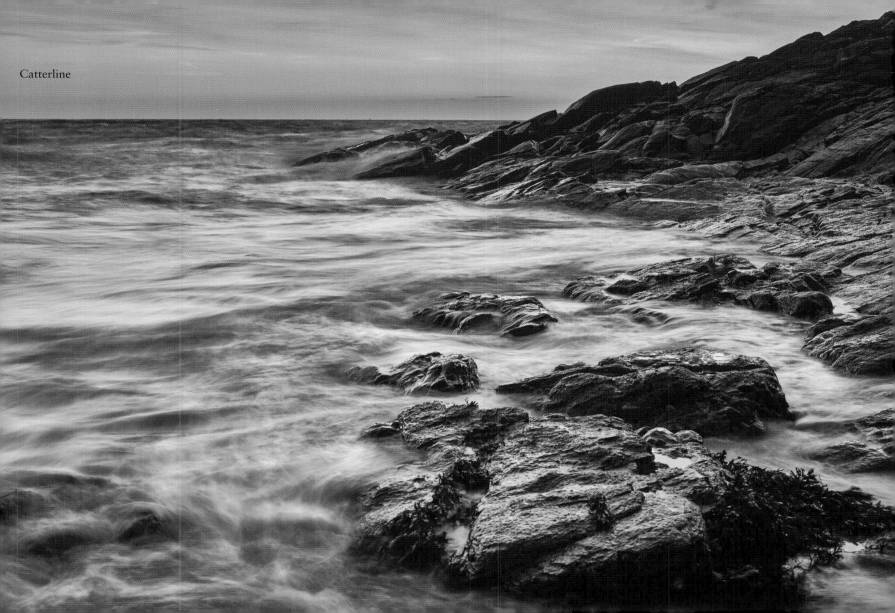

Catterline

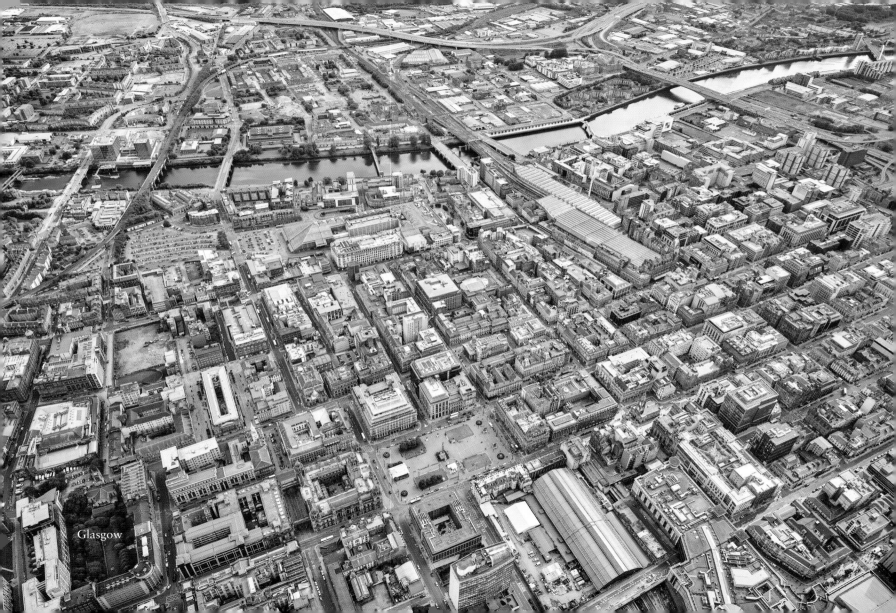

Glasgow

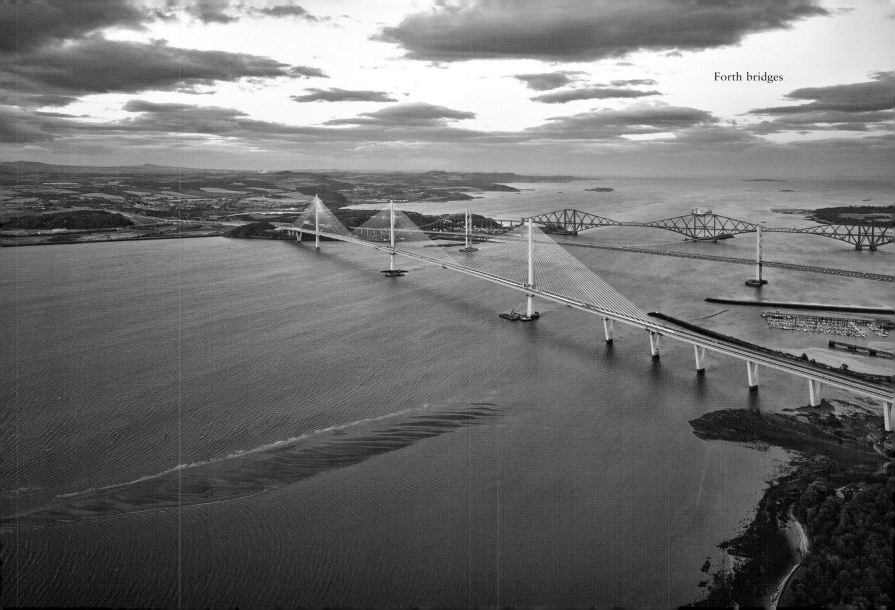

Forth bridges

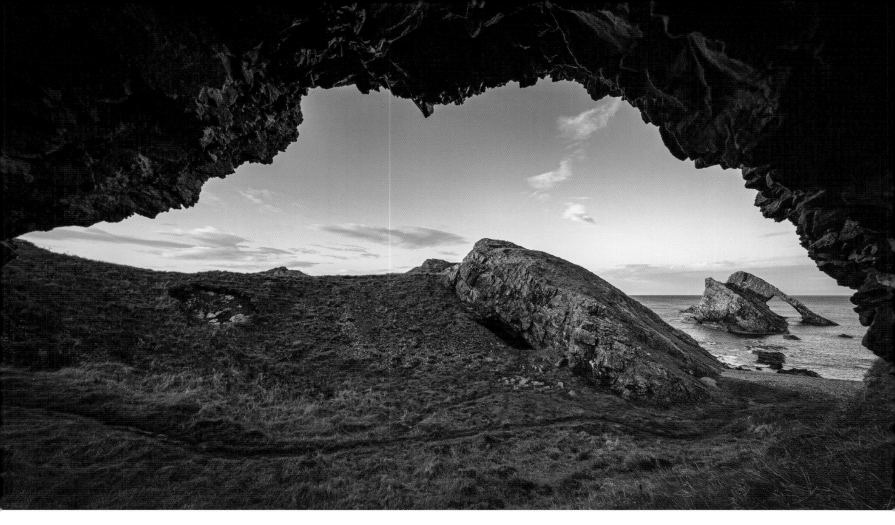

Bow Fiddle Rock, Portknockie

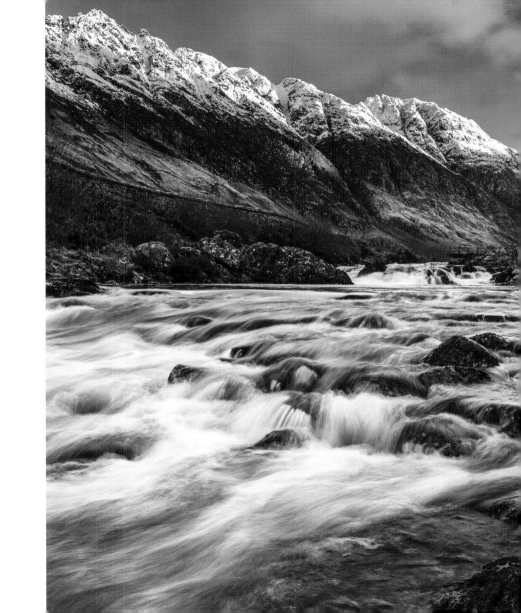

Loch Achtriochtan

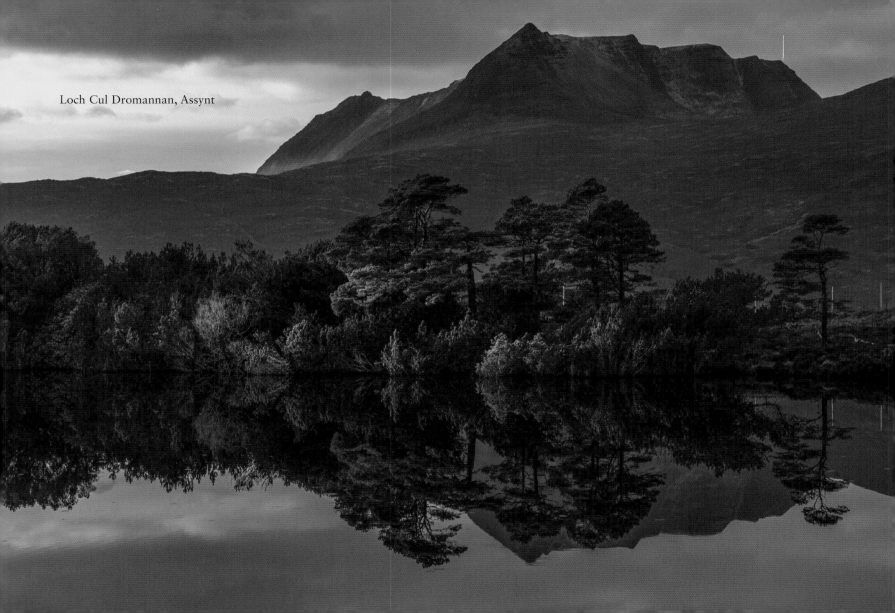

Loch Cul Dromannan, Assynt

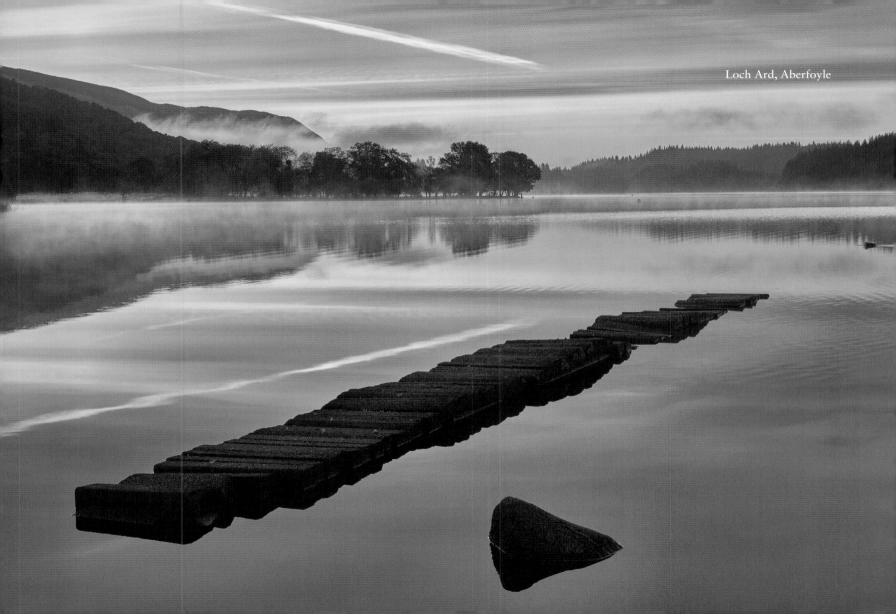

Loch Ard, Aberfoyle

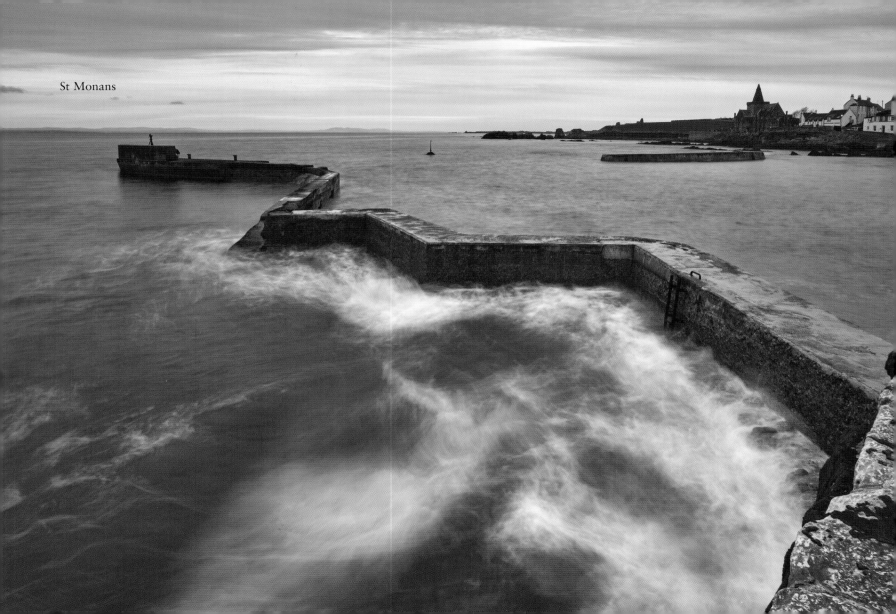

St Monans

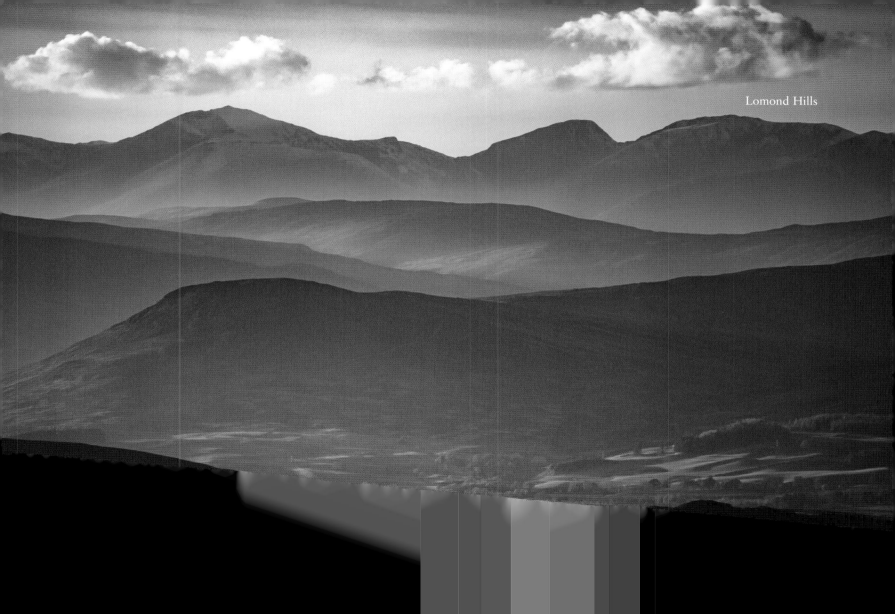

Lomond Hills

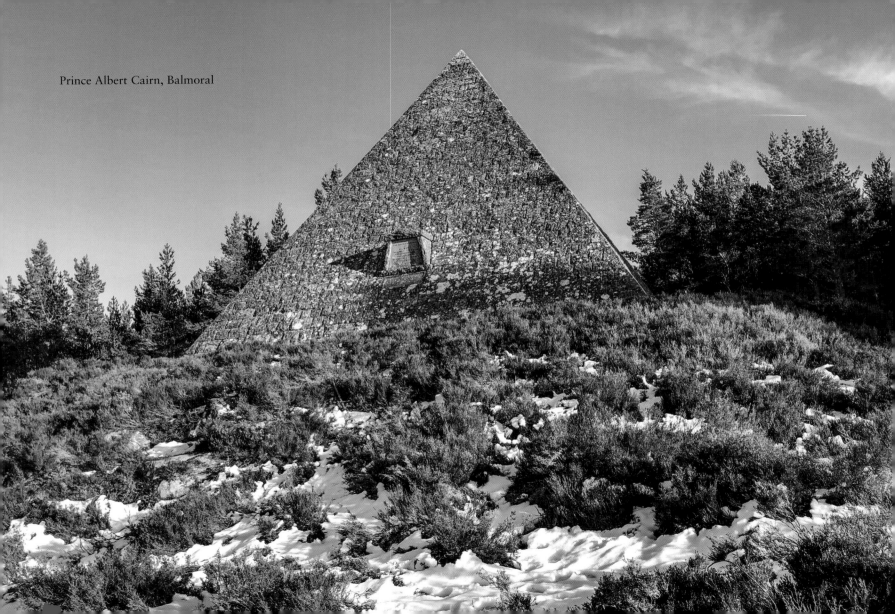

Prince Albert Cairn, Balmoral

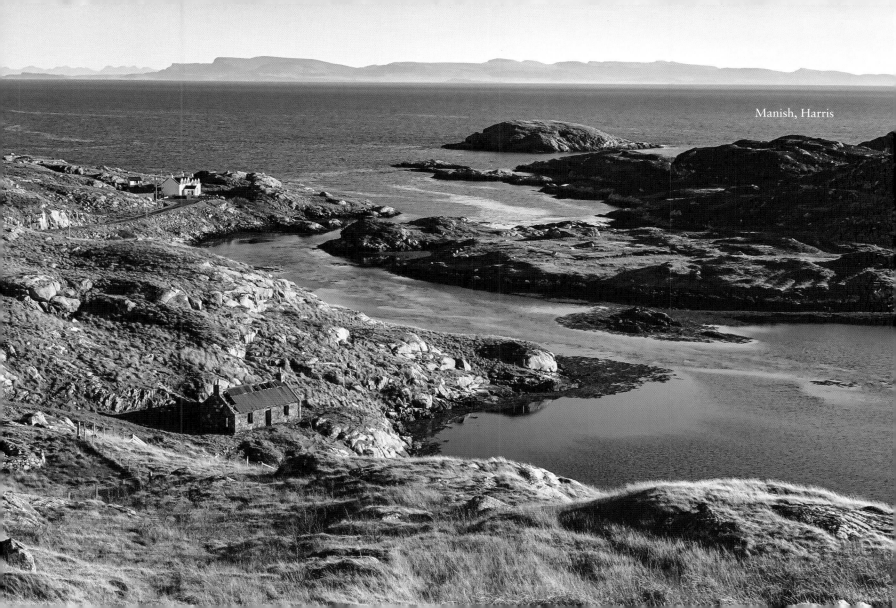

Manish, Harris

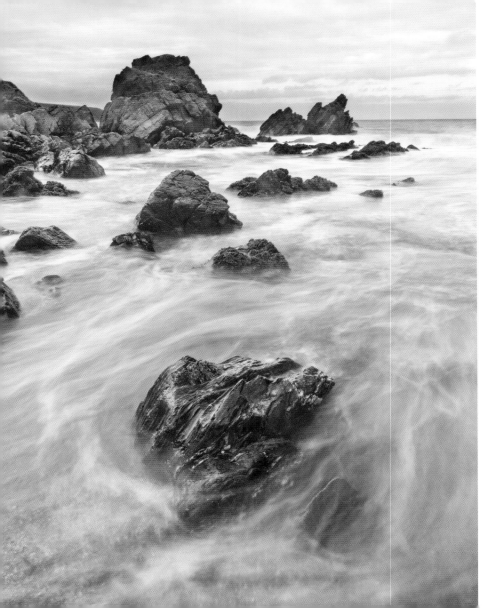

Skatie Shore

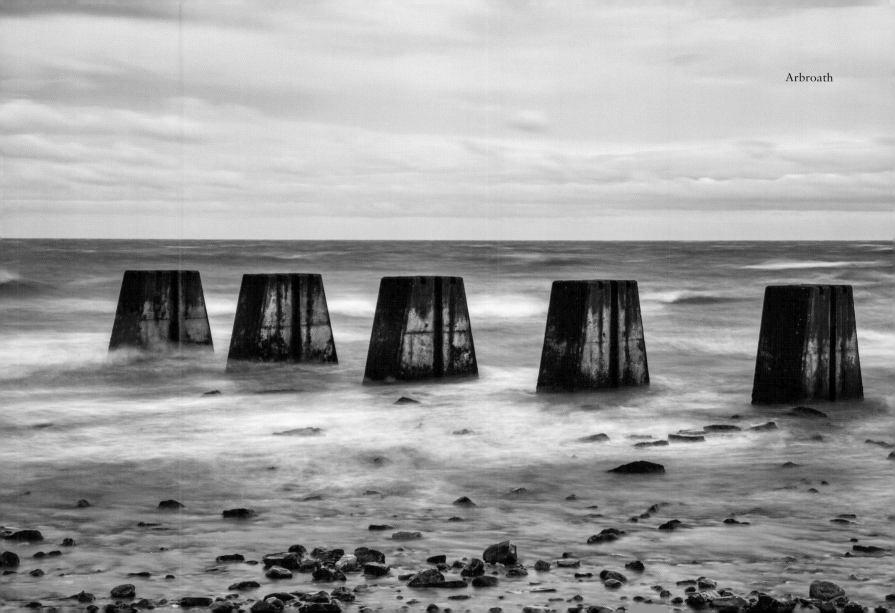
Arbroath

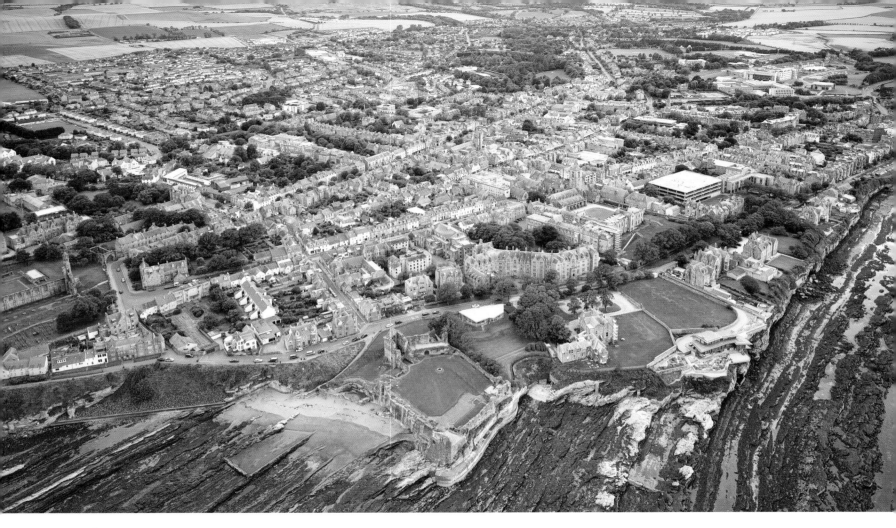

St Andrews

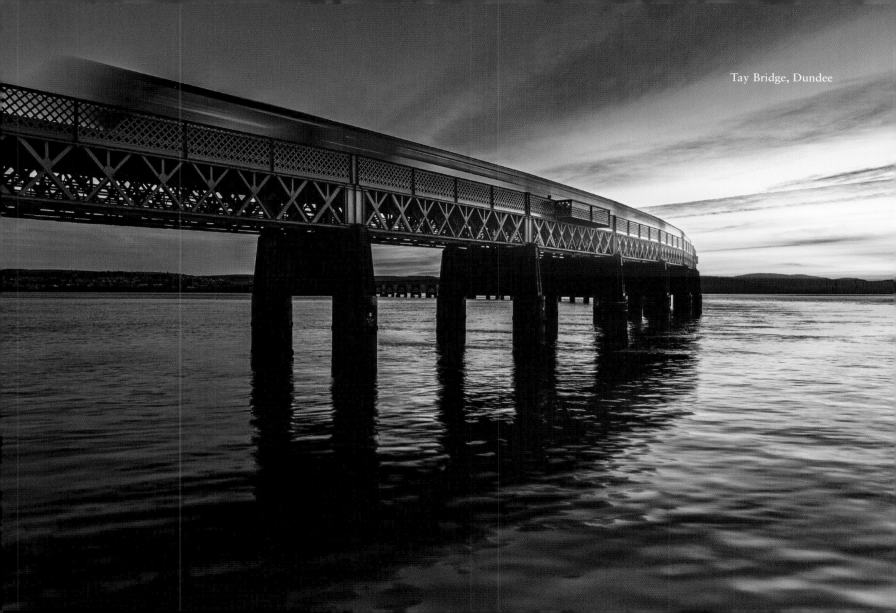
Tay Bridge, Dundee

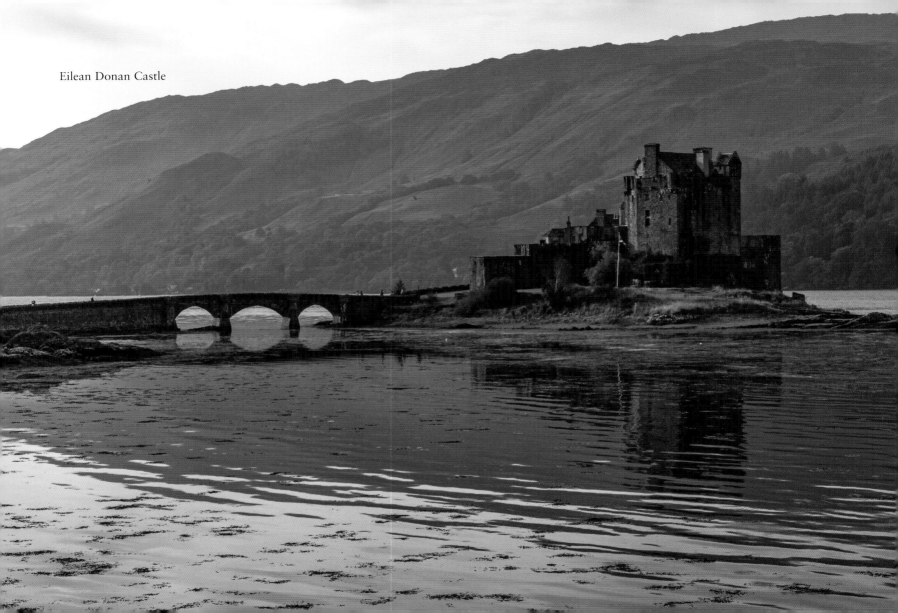

Eilean Donan Castle

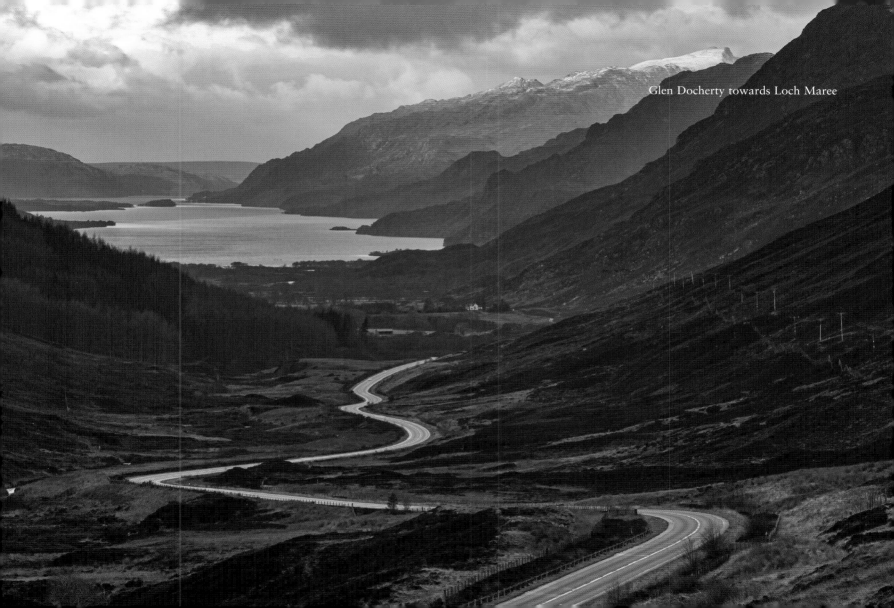

Glen Docherty towards Loch Maree

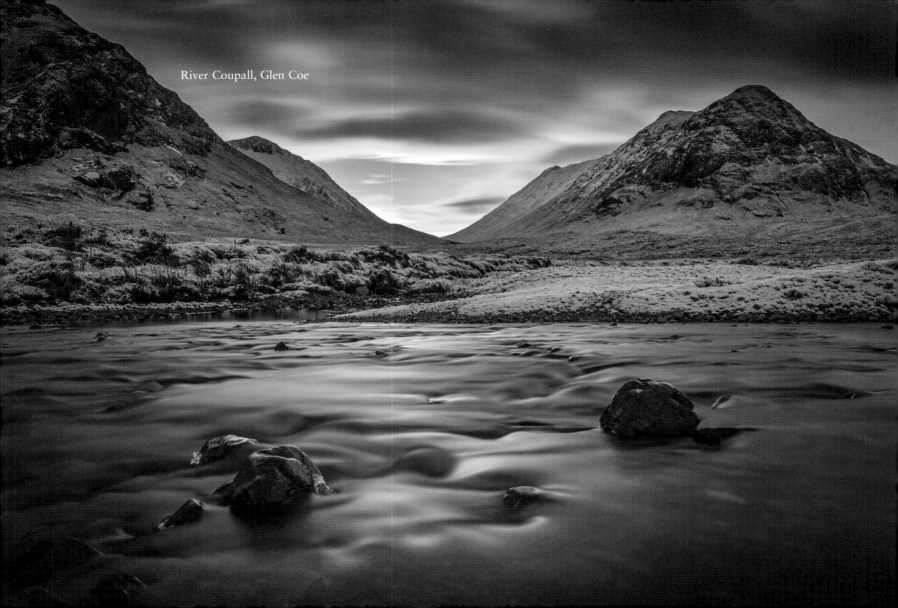

River Coupall, Glen Coe

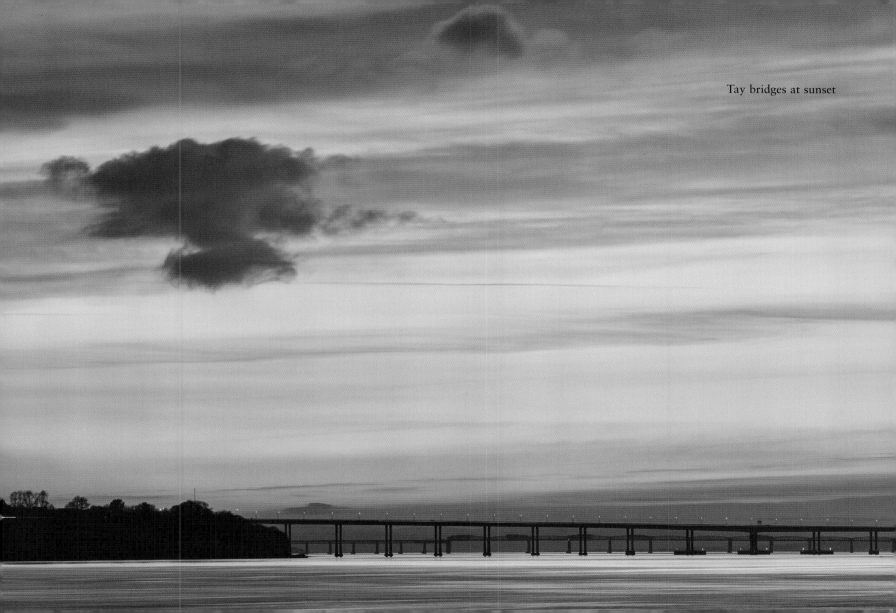

Tay bridges at sunset

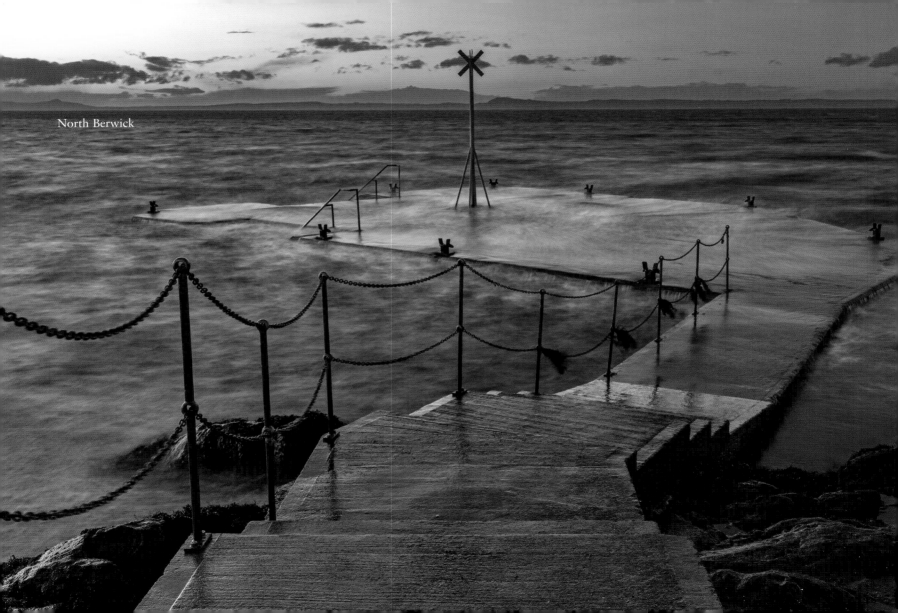

North Berwick

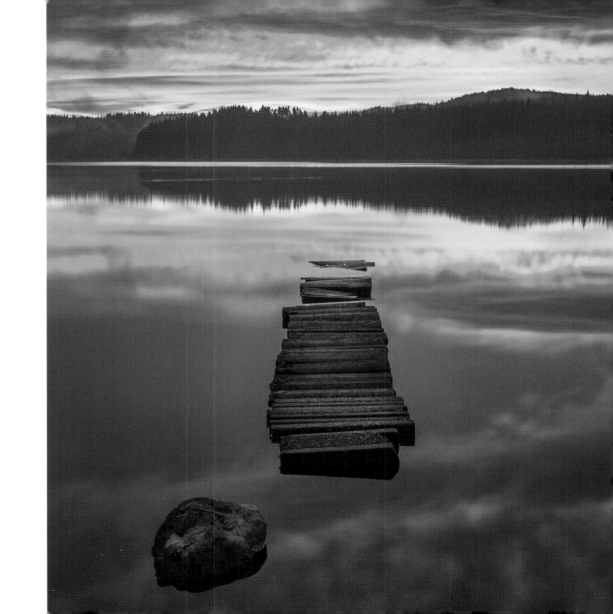

Loch Ard

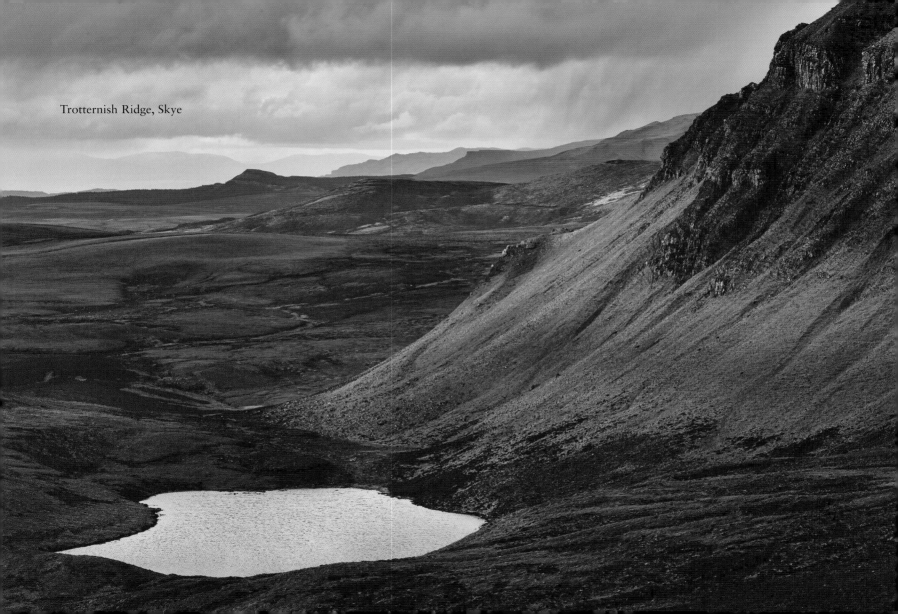

Trotternish Ridge, Skye

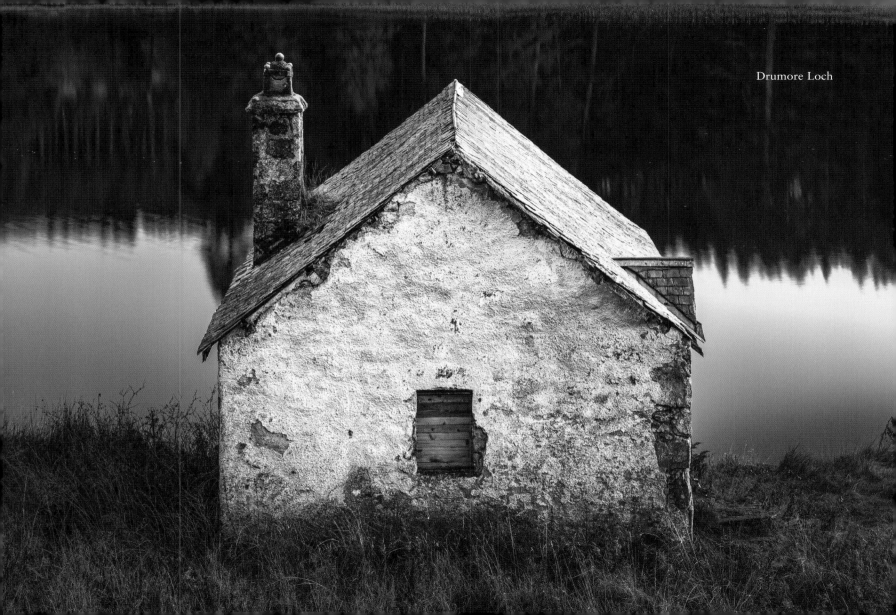

Drumore Loch

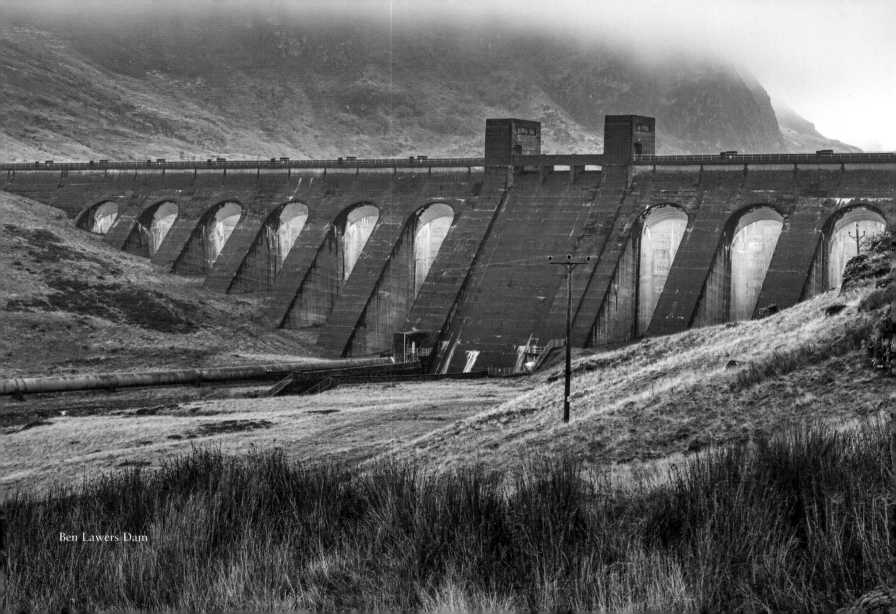

Ben Lawers Dam

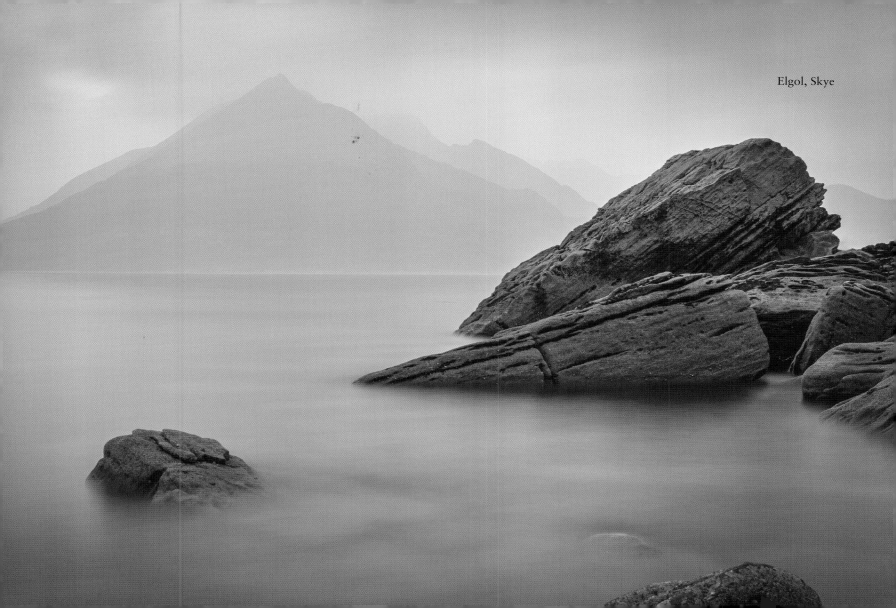

Elgol, Skye

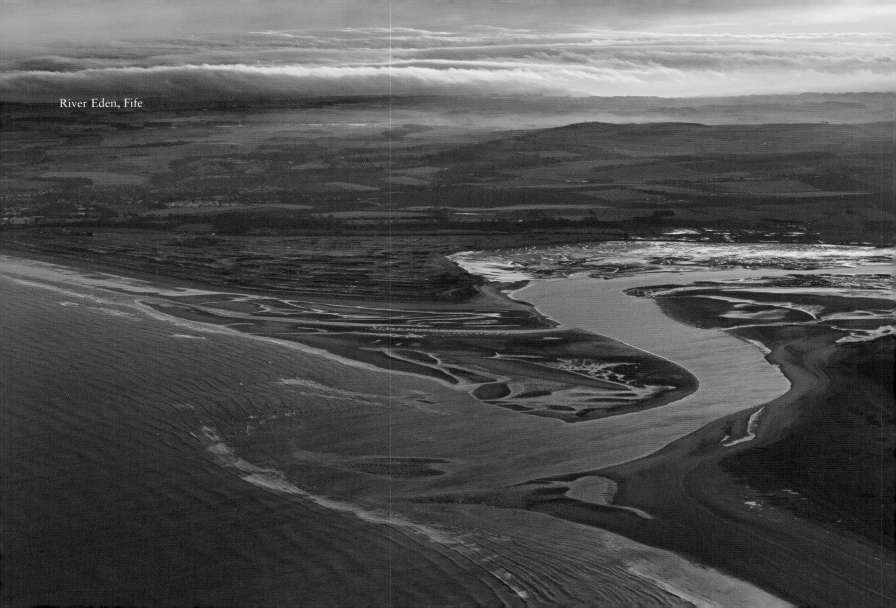

River Eden, Fife

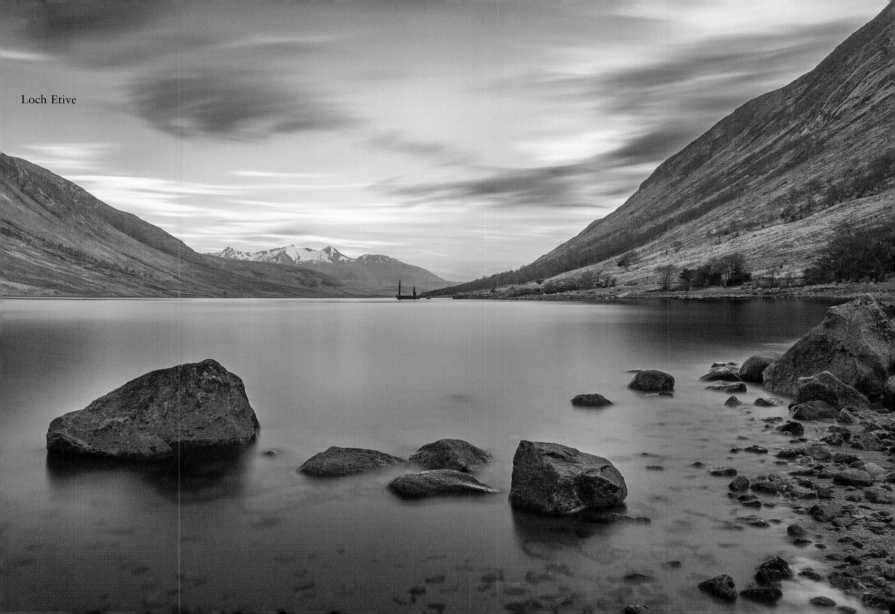

Loch Etive

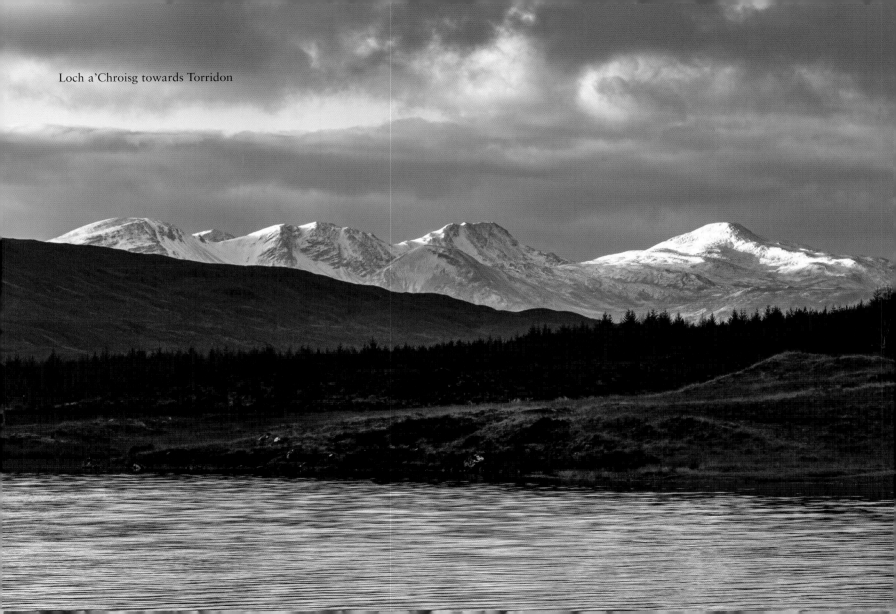

Loch a'Chroisg towards Torridon

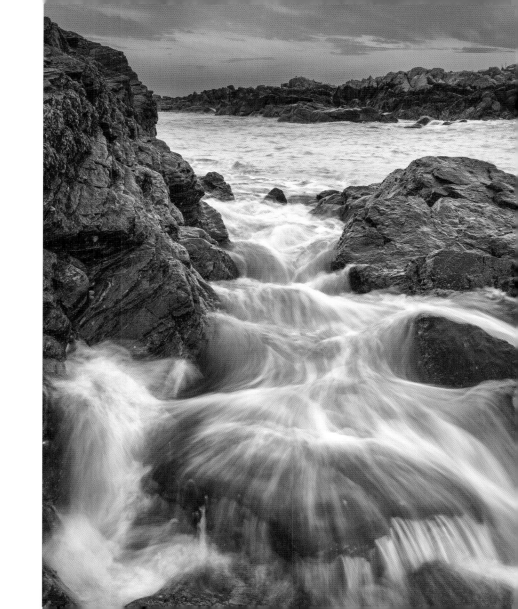

Cove Bay

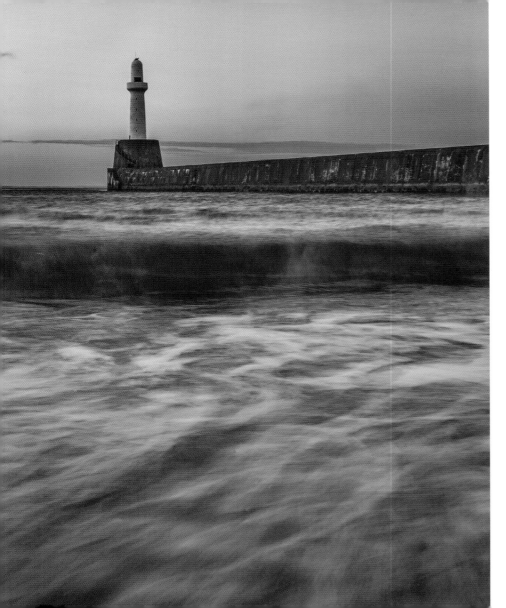

Torry Point

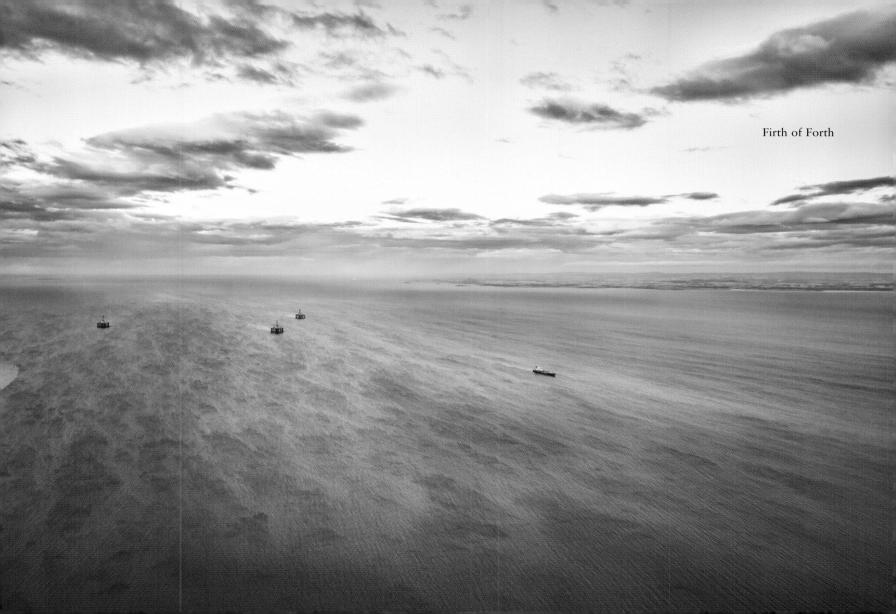

Firth of Forth

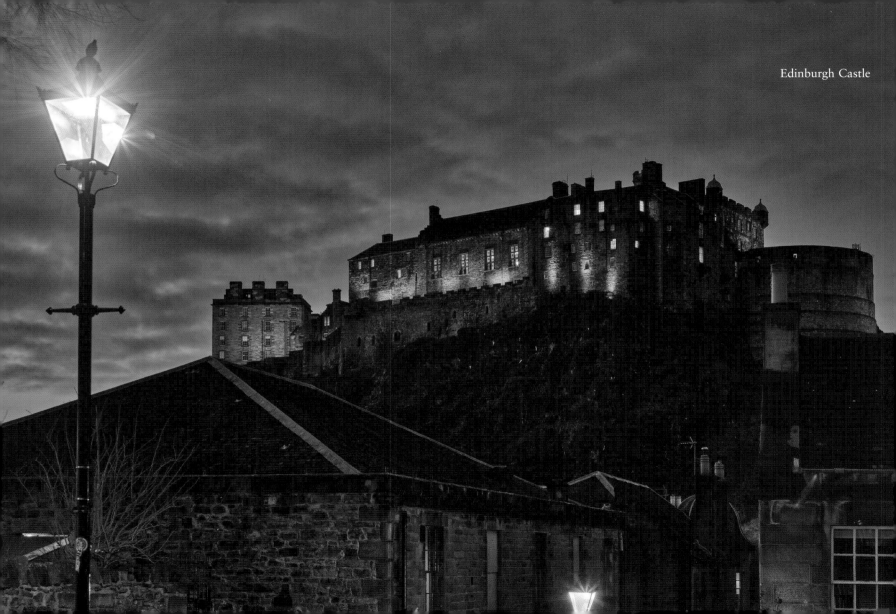

Edinburgh Castle

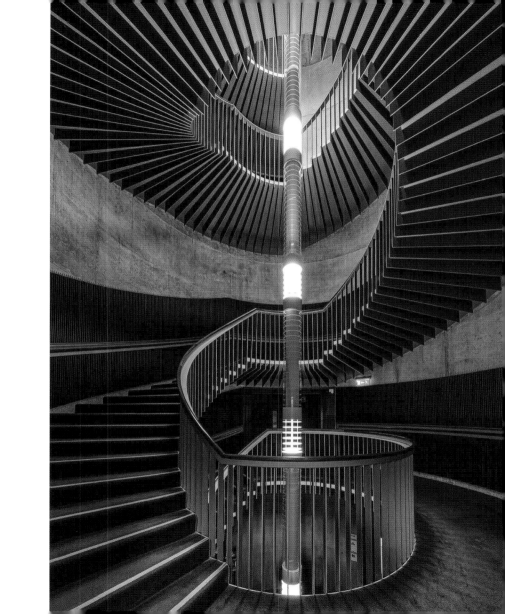

Usher Hall, Edinburgh

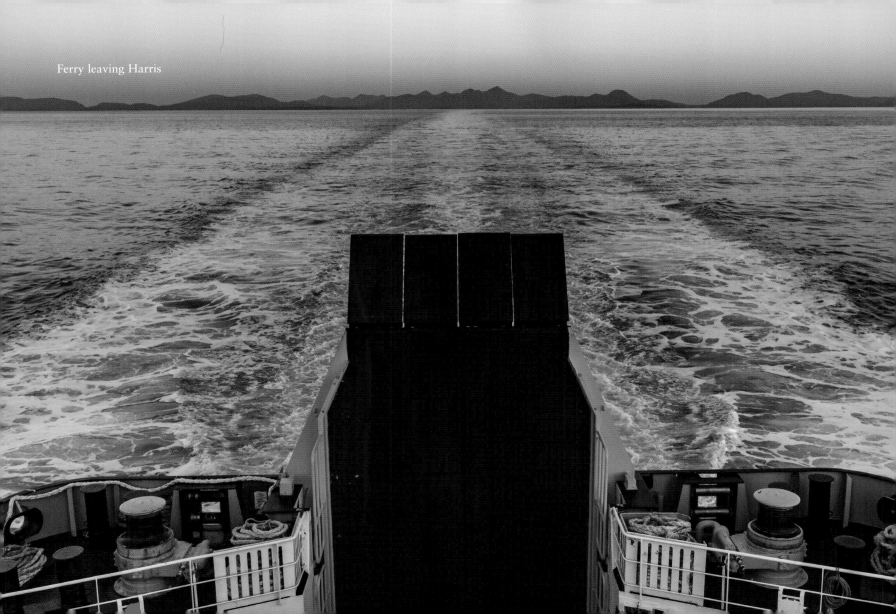

Ferry leaving Harris

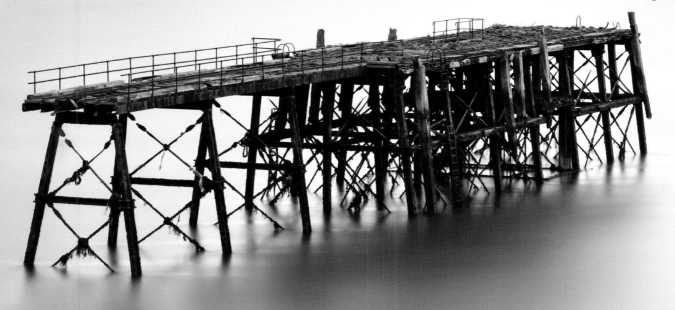

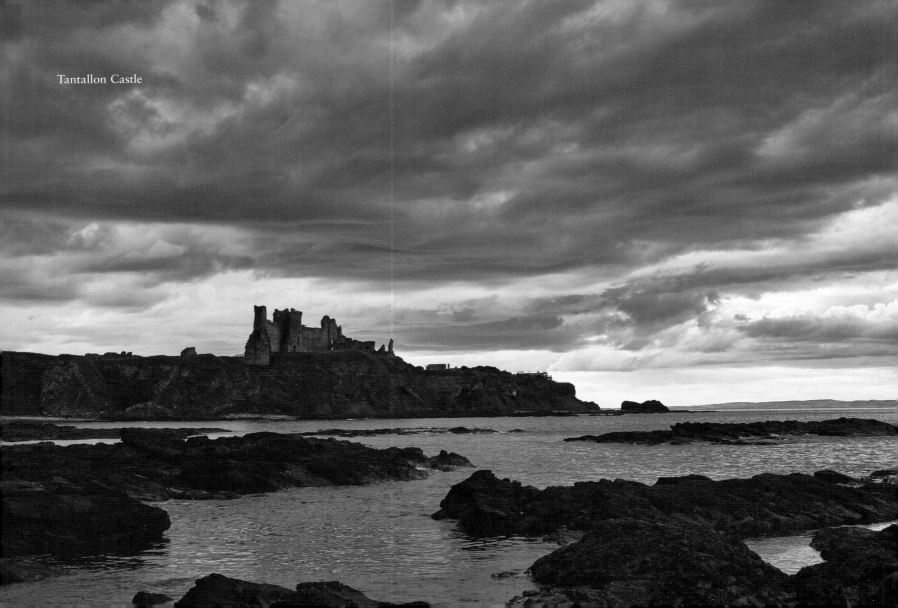

Tantallon Castle

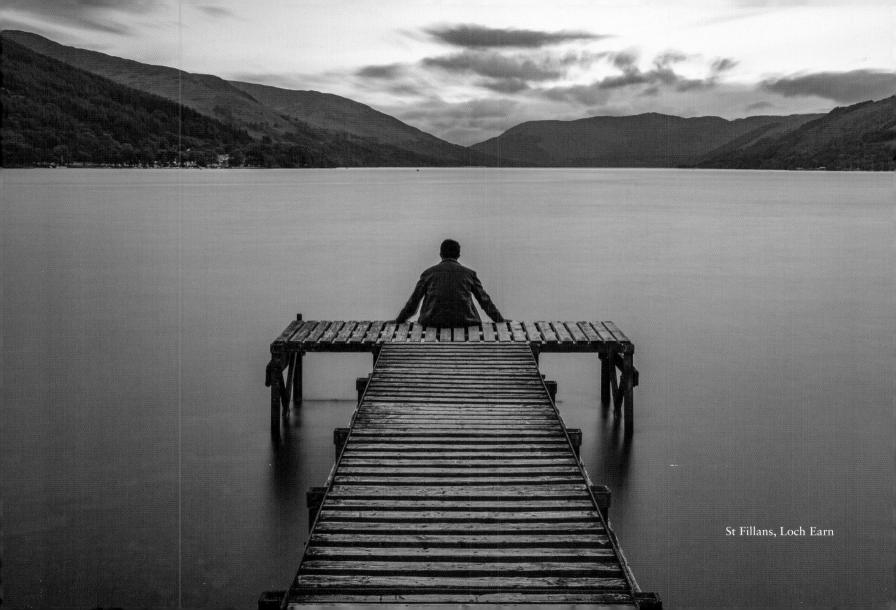

St Fillans, Loch Earn

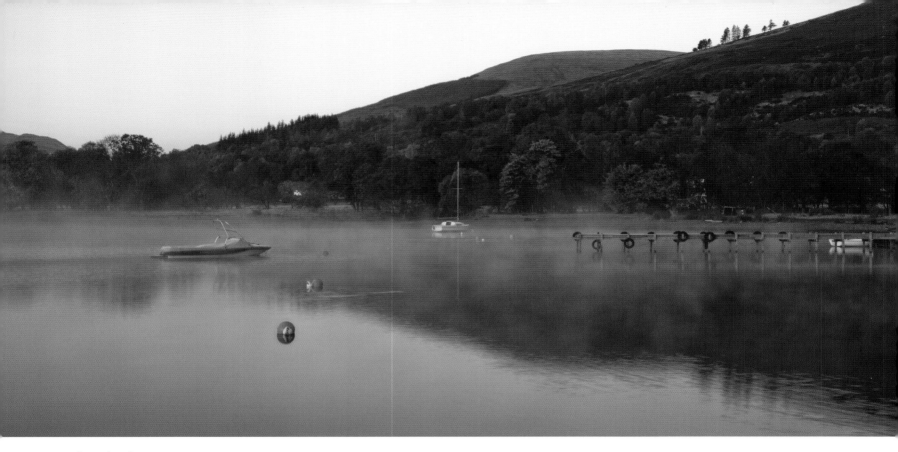

Lochearnhead

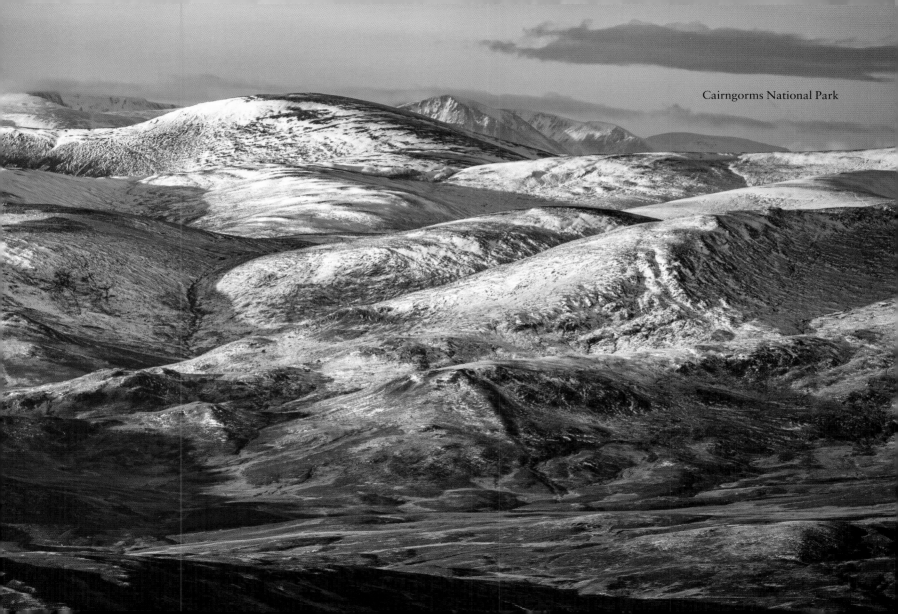

Cairngorms National Park

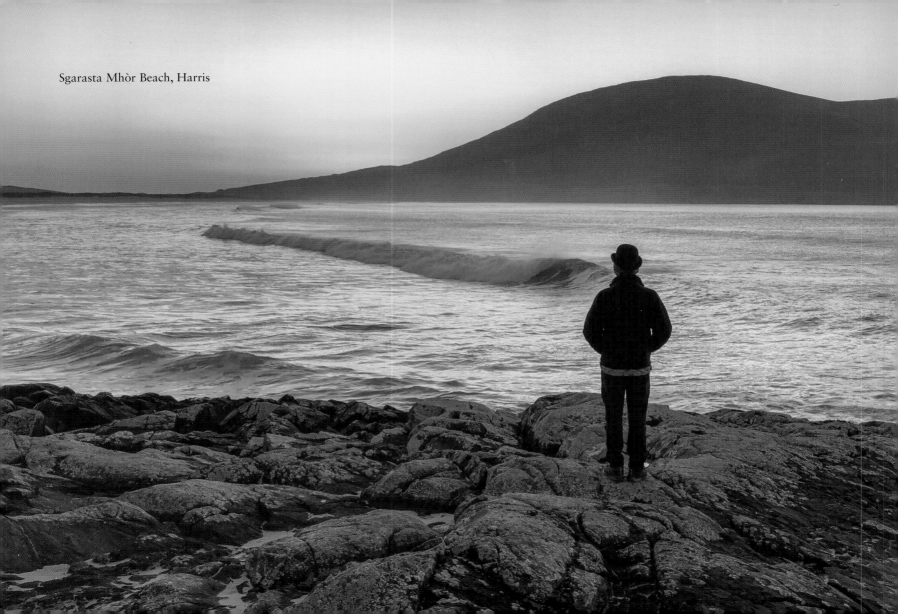

Sgarasta Mhòr Beach, Harris